MURDER

— ON —

LONG ISLAND

A NINETEENTH-CENTURY TALE OF TRAGEDY & REVENGE

GEOFFREY K. FLEMING & AMY K. FOLK

Charleston • London

THE
History
PRESS

Published by The History Press
Charleston, SC 29403
www.historypress.net

First published 2013

Manufactured in the United States

ISBN 978.1.62619.003.0

Library of Congress CIP data applied for.

CONTENTS

Foreword, by Joseph Wickham 5
Acknowledgements 7

1. The Wickham Family and Cutchogue 9
2. Nicholas Behan and Ellen Holland 18
3. The Dismissal 26
4. The Murder 31
5. The Hunt for Behan 40
6. The Lawyers 46
7. The Press 53
8. Tourism 60
9. The Trial 65
10. The Verdict 83
11. The Aftermath 91
12. The People 96

Notes 103
Bibliography 121
About the Authors 128

FOREWORD

The American movie actress Joan Crawford once said, "Not knowing how it all ends is the most important element in having a happy life." Certainly that would apply to my great-great-great uncle, James Wickham, and his wife, Frances. By all accounts, they were a happy couple. Wealthy, politically connected, talented and hardworking, their future possibilities seemed limitless. Retreating from the big city, they opted for quiet country lives on the bucolic Cutchogue, Long Island, waterfront, surrounded by friends and family who respected and loved them.

Instead of living into their golden years, they were savagely murdered with an ax by an insane farm worker. Their sudden, violent, senseless and bloody demise shocked their community and continues to echo through the ages. Though tame by today's standard of mass killings by lunatics at schools, malls and movie theaters, the irrational act was a harbinger of a violent, insanity-fueled future society with which America is now grappling.

When I was growing up, my grandfather would often tell the story of the Wickham ax murders as we all sat around the dinner table. This story was one of many in Wickham family lore, though perhaps the most memorable. All us grandchildren would sit there with wide eyes as we tried to imagine the horror of being chopped up alive. Afterwards, I would go to bed and lay there wondering if I was also doomed for a violent end, perhaps that very night. I found out later that I often stayed in the same bedroom where the murders occurred. Some say there are ghosts in that bedroom, but I never saw any. On the other hand, I am a very sound sleeper.

FOREWORD

The story of the Wickham ax murders is much more than a lurid tale of sudden death. It is also an inspiring story of a grievously shocked community that united to track down a killer. It is a story about a family fortune teetering on the fickle fingers of fate. It is a story about justice triumphing over a heinous crime. Most importantly, it is a story about a humane couple named James and Frances Wickham, who made a courageous decision to protect a young woman from a bully and ended up paying the ultimate price.

Joseph S. Wickham
December 14, 2012

ACKNOWLEDGEMENTS

A book like this one takes the effort of many different people, all of whom deserve our gratitude. Thanks are due to Ruth Ann Bramson, president of East Marion Association and Oysterponds Historical Society (OHS), for her help in obtaining permissions to reproduce images from the OHS collection; Kathy Curran, director of the Suffolk County Historical Society (SCHS), for her help in obtaining permissions to reproduce images from the SCHS collection; Robert Delap, rights and reproductions assistant at the New-York Historical Society, for his help in searching out the splendid portrait of Attorney General Ogden Hoffman and helping us to obtain permission to reproduce it; James Grathwohl, independent historian, for his help in making vital connections for us; Walter R. Jackson, office assistant for the Southold Historical Society, for being his usual helpful self; Rena Doughty McWilliams of Texas Genealogy Web for her help in tracking down some long departed former residents; Mariella Ostroski, librarian of the Historic Room at the Cutchogue-New Suffolk Free Library, for her help in obtaining images and research on the topic of the Wickham Murders; Sharon Pullen, archivist at the Suffolk County Historic Documents Library, for her research assistance; Edward Smith III, archivist at the SCHS, for his help in securing images and other information on the Wickham Murders; Jeff Walden, research librarian at Mattituck-Laurel Library, for being his usual helpful self; and Deanna Walker, office administrator at the Southold Historical Society, for putting up with me and Amy during this project. A very special thanks to the many members of the Wickham family who aided

ACKNOWLEDGEMENTS

us in our quest to tell this story, including Mary Lou and John Wickham, Prudence Wickham, Gekee and Thomas Wickham and Joseph Wickham, the family historian whose great research and documentation of his family was immensely helpful to us.

Additional thanks are due to our friends at The History Press, who help make the revealing of stories like this one possible. A very special thanks to our project coordinator, Whitney Tarella Landis, and her team for also putting up with Amy and me during this "Herculean effort."

Geoffrey K. Fleming and Amy Kasuga Folk

THE WICKHAM FAMILY AND CUTCHOGUE

In the shadow of New York City lies one of the longest islands in the United States. Appropriately named Long Island, the land is shaped like a fish with a body that extends eastward out from the city and into the Atlantic Ocean. To the north of the island separated by Long Island Sound are the states of Connecticut and Rhode Island.

Approximately 130 miles long, the island today supports a variety of communities. On the western end are interconnecting urban communities that are part of the sprawl of Manhattan. The center of the island is covered in miles of suburbia with row after row of quarter-acre houses and shopping malls. At the far eastern end, the land divides to form the fish tail, also known as the South Fork and the North Fork. The South Fork, the more well known of the two forks, is the home and playground of a number of wealthy and famous people and thousands of vacationers. In contrast, the North Fork is among one of the few rural areas left on the island. Prior to World War II, the vast majority of Long Island once resembled the North Fork, with nothing but miles of farmer's fields from New York City out to the far east end. The western end of Long Island was originally settled by the Dutch when New Amsterdam was founded on what is today more familiarly known as Manhattan. As the colony grew, it started to spread into the surrounding islands, forming communities such as Brooklyn and New Utrecht. Although claimed by the Dutch, the eastern end of the island was actually settled by the English when colonists from New England traveled south to set up communities on the forks.

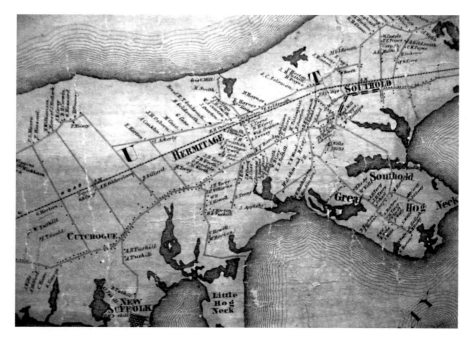

An 1858 Chace map of Long Island showing the hamlets of Cutchogue, Hermitage (Peconic) and Southold. *Courtesy of Southold Historical Society.*

Unlike Southampton, which started as an independent colony, Southold began sometime around 1640 as a plantation of the New Haven Colony in Connecticut. The land had to be purchased twice—once from the Native Americans by representatives of the New Haven Colonies and again from James Farrett, who was the agent representing Lord Stirling, the British noble granted the land by the Crown. Settlers from Connecticut, led by Reverend John Young, set out to create an English community on the land.[1] For a decade, the area was officially a plantation and not a colony, and residents of Southold had no local government. Landowners had to sail across Long Island Sound to Connecticut to transact all legal matters. Land sales, complaints about neighbors and voting all had to be taken care of in New Haven. Not until June 25, 1649, did Southold purchase its independence from New Haven and set up a locally controlled government.[2] Governor Andros didn't formally recognize the new town until October 31, 1676.[3]

Southold was modeled after many of the colonial governments around it, and as such, only landowning white males who were members of the church had the right to participate in government.[4] In essence, the town

government was run by the church—a theocracy. The inhabitants who were qualified to vote were expected to help run the government. Men gathered annually to be elected to jobs such as fence viewer, sheriff and road overseer.

Originally, Southold Town encompassed the entire North Fork and about ten miles west on the main body of the island. But as time passed and newcomers moved into the area, the number of farms and far-flung distances made the centralized community difficult to manage. In 1661, the town divided itself into three sections. To the east, the Oysterponds division was made, and to the west, the Cutchogue and Occabauck divisions were created.[5]

The communities along the fork stretched from the Long Island Sound to Peconic Bay and formed a series of strips next to each other. Starting from the eastern end formed from the Oysterponds division were the hamlets of Orient and East Marion. Then, moving westward, Greenport, Hashamomaque and Southold evolved from the original Southold community. On the western side of Southold were Peconic, Cutchogue and Mattituck of the Cutchogue division.[6] The Occabauck division included Franklinville, which became Laurel, Jamesport, Northville, Aquebogue, Riverhead, Calverton and Wading River.

One of the first areas to split off from the original plantation was Cutchogue. The name Cutchogue is derived from the word Kehtchi-auke, which in the local Native American language means "the principal place." The name in the early records can be alternately spelled Cachauk, Cautchchaug or Corchaug, depending on the writer.[7] The local tribes inhabited the southern area of the hamlet known as Fort Corchaug, where the Native Americans had their main village and fort.[8] After the settlers convinced the local tribes to sell the land, the tribes simply faded from the local historic record. Whether they moved away or died in mass numbers from new diseases brought by the Europeans was not noted by the local sources.

The newcomers divided the land of the Cutchogue division into forty-four lots, each about 120 acres. All of the lots were split among twenty-one owners.[9] The original boundaries of the division stretched from the western edge of Southold in what is today Peconic to the base of Mattituck Inlet on the eastern edge of the partition. Over time, the original lots were divided up and sold or traded among the residents for land in other areas.

The hamlet of Cutchogue is framed to the north by Long Island Sound and in the south by Peconic Bay. To the west is Mattituck, which was formed from the Cutchogue division almost as soon as the new community was created. To the east is the neighborhood of Peconic. The southern shore of

Cutchogue is flat, but as you move to the north, the land rises into a series of gentle hills that were called Manor Hills. The area during the colonial period through the mid-nineteenth century had one road that crossed from west to east, bisecting the entire North Fork, appropriately called Main Road. Four smaller roads traveled from the center of the hamlet toward the far northern section of Cutchogue, which was nicknamed Oregon.[10] Two roads travel south, one toward the community of New Suffolk and the other to Little Hog Neck, now known as Nassau Point. It was to this area that Joseph Wickham (1662–1734) eventually moved his family.[11] In 1686, Wickham moved from Killingworth, Connecticut, to Southampton Town with a land grant that set two conditions for ownership. First, he had to set up his own business as a tanner along the shores of Sagg Pond in Sagaponack, and second, he had to stay for a period of seven years.[12] Wickham married twice and had ten children. When his contract ended in 1698, he moved his family to Cutchogue.[13] There he purchased a farm and house from Joseph Horton, who had inherited the farm from his brother Benjamin. The property was described as being located on the western edge of "Broad Fields," which was located in the center of Cutchogue. Amassing property in the area, Joseph expanded the size of his new farm, extending it southward toward Peconic Bay. Among his more notable purchases was Robin's Island, a 435-acre island located in Peconic Bay.[14]

The family continued to prosper, with Joseph's eldest son Joseph Jr. (1701–49) marrying Abigail Parker (1703–80) in 1723. They raised nine of their eleven children to adulthood.[15] Joseph Jr. started a tradition of service to the community in law and/or government that each generation of Wickhams continued. Beginning in 1703, Joseph Wickham Jr. served as the local constable. He was the collector of taxes in 1709, and he served as commissioner of highways in 1718, 1726, 1728 and 1745–46. He acted as an overseer in 1735, an assessor in 1743 and the overseer of the poor in 1747.[16] By 1748, he had earned the nickname "Justice Wickham in Southold," although according to local records, he did not hold a judgeship within the town.[17] While it was expected that landholders of the area take an active part in government, Wickham took it even further, remaining active almost up to his death.

Parker Wickham (1727–85) was the eldest son of Joseph Jr. Like his father, Parker was active in local government, holding similar posts as his father and eventually becoming town supervisor in 1770, an office he held until 1777.[18] Parker was a man caught between a rock and a hard place during the American Revolution, and not everyone in town was sympathetic to his

situation. Elected to one of the highest posts available in the town, he was expected to uphold legitimate British rule even when the vast majority of his neighbors did not support the loyalist government. It is possible that the Wickham family followed the same strategy many other east-end families used—one member of the family proclaimed himself in support of the government and signed the oath of allegiance to the king while the rest of the family departed for Connecticut in support of the rebellion. It was hoped that by having a representative on each side of the conflict the family's property would come through the hostilities intact for the next generation. Parker, with his position, was the sacrificial lamb.

However, it is also possible that he did believe in and support the system of government he had served for so long. Toward the end of the war, Parker saw that the British were not going to prevail, and to protect the family property, he transferred ownership of his holdings to his mother and his son Joseph Parker, both of whom had remained politically neutral. Wickham had undoubtedly hoped that the land, which consisted of 240 acres and the house his grandfather had purchased in Cutchogue plus Robins Island, would remain in the family when the war ended and the new government took over.[19] But that hope was not realized. Enemies of Wickham put his name on the forfeiture of property list of the new government, and the force of the new laws steamrolled over the provisions that the family had made. The farm and Robins Island were seized and sold at auction. The land in Cutchogue was purchased by Jared Landon of Southold, while Ezra L'Hommedieu bought the island.[20] Parker Wickham left New York and moved to Connecticut, never to return. He died shortly thereafter in New London.[21] His eldest son, Joseph Parker, who had spent the later part of the war in the Caribbean, came home when he got the news about his father's death and the loss of the farm. He petitioned both the British government and the new state government for the return of the property, which was in his name. In 1789, instead of receiving the house and farm, he was awarded £2,800 in compensation.[22]

Even with this blow to the Wickhams' holdings, other branches of the family were still very much a presence in the community. After the revolution, Joseph Parker's eldest sister Parnel (1757–93) married James Reeve (c. 1756–1830), who was also from Cutchogue and had served in the local patriot regiments in Connecticut. They had a daughter, Anna Reeve (1782–1825). Anna Reeve married William Wickham (1773–1859), whose father was Parker Wickham's younger brother John (1734–1808).[23] The new couple moved into John Wickham's farm, which William inherited in 1808

on the western end of Cutchogue. William and Anna had seven children: James (1804–54), Parnel (1807–86), Elizabeth (1813–85), John (1810–91), Hannah Nancy (1816–?), William (1819–81) and Henry (1823–93).[24]

James Wickham was the eldest son of William and Anna, born in Cutchogue just after the start of the new decade. While there is no information on his childhood, he was probably educated locally along with his brothers and sisters. The family attended the Cutchogue Presbyterian Church, where his father, William Wickham Sr., was a trustee. Likewise, there is no record of James's movements after he came into adulthood. Like most young men, he probably continued working on his father's farm until he decided what he wanted to do with his life. Sometime in the 1840s, James decided to make his fortune away from Cutchogue. All of the current recounting of James Wickham and the tragedy that befell him state that prior to purchasing the farm in Cutchogue he was living in Brooklyn making his fortune as a grocer. While there was a man named James Wickham involved in the grocery business in Brooklyn, he is not James Wickham from Cutchogue.

There are literally hundreds of men named James Wickham who have lived and died in the United States. In 1850, there were three men named James Wickham living in New York State. One was living in Syracuse and after 1854 worked as a lamplighter in the city. The other two men named James Wickham were involved in business either as a grocer or as a storekeeper. One was living in Brooklyn and was married to a woman named Elizabeth and had several children.[25] The other was moving around in upstate New York and is noted only by advertisements of letters waiting for him at the post office and by notices he placed in the newspapers for his business.

James Wickham of Cutchogue was the man in upstate New York. He first appears in lists of people who have letters waiting for them in the local post office at Silver Creek, New York, in 1839.[26] Silver Creek was located on the western edge of New York State near Buffalo, just north of Fredonia. His occupation at the time is unknown.

On May 5, 1847, James Wickham returned to Long Island to marry Frances Post at the Westhampton Presbyterian Church in Westhampton, Long Island.[27] Frances was the youngest and sixth child of Abraham Post (1775–1866) and Sarah Howell (1779–1838). She was born in Southampton Town on May 31, 1821. Frances' father, Abraham Post, was noted several times in the *Sag Harbor Corrector* for being involved in two bankruptcy proceedings after the death of her mother.[28] Frances Post was an older bride, twenty-six when she married, and there was a seventeen-year difference

between the bride and groom. It is possible that James Wickham and Frances Post met when she was visiting her relatives in Mattituck.[29]

More of James Wickham's life is apparent in the newspaper articles after his death. He did spend some time in the Syracuse area, where he was a partner in the grocery firm Wickham and Carwin.[30] Another paper stated that he ran a grocery in Fulton, New York, which is just north of Syracuse.[31] He next appears to have branched out into his own business. In advertisements run in the local papers of Syracuse, Wickham is listed as the proprietor of a paper/stationery store from autumn of 1850 to as late as the spring of 1851.[32] When James retired to become a farmer, he was financially well-to-do. He had invested in businesses other than his own and was possibly receiving a good return on those shares.[33] Upon his death, James Wickham's property and personal estate was valued at $20,600.

Life in Cutchogue

In the 1850s, the community of Cutchogue was a mixture of farms and homes. Most residents had their homes clustered along the Main Road in the center of the hamlet. Few houses were situated outside the downtown area. The region was known for its farmland and abundant yields. Books describing Cutchogue during the era noted that farmers used not only the fish known as menhaden or bunker to fertilize the fields but also seaweed and grasses with outstanding results.[34]

Cutchogue's business district was centered along the main thoroughfare. During the mid-nineteenth century, residents had the choice of shopping in one of the two general stores. Located in the center of downtown was the store owned by William Betts, which also housed the local post office. On the eastern edge of town, H.H. Case ran another store dealing in dry goods and groceries. Interestingly, general stores at this time period often acted as the local saloon. Customers could purchase rum or other alcoholic beverages by the glass or by the bottle. Credit would have been extended to any newcomer who came with a recommendation from a solid local citizen.[35]

Farmers had a number of services available locally. Those who wanted to handle the sale of their own crops in New York City or Brooklyn could take advantage of the numerous ships and ferries that made regularly scheduled trips up and down the sound.[36] For those who didn't want the extra work of finding buyers for their crops, O.B. Corey's marketman business would act

as a middleman between farmer and market. His establishment was located on the north side of Main Road.[37] A local harness shop and two blacksmith shops were also located in the community.

O.T. Goldsmith and his partner A.B. Tuthill advertised themselves as dealers in "lumber, bricks, posts, bails, locust posts, stone, lime, cement and farmers' tools."[38] Not to be outdone, both of the general stores advertised that they carried tools for farmers as well. Residents who wanted an alternative did not have to go to Goldsmith & Tuthill; they could also patronize L.B. Tuthill, who manufactured and sold bricks from the corner of Main Road and the road leading south to New Suffolk. J.H. Terry, a professional mason, also lived nearby.

There were two churches to serve the residents of Cutchogue. The Presbyterian church was built in 1737, and a Methodist church was erected around 1829.[39] Three different schools were situated along the north side of the Main Road, and a shoemaker had a shop on the western side of the hamlet. The area must have been busy with visitors, because both William Betts, the general store owner, and J.B. Tuthill publicized their establishments as hotels. Cutchogue also had a lyceum, which included a stage and lecture hall for concerts, speeches and plays.

Situated among this prosperous rural community was the farm of the late Joseph C. Albertson. Josiah Albertson, who held the mortgage on the farm, forced the will's executors, Hutchinson H. Case and Albert Albertson, to sell it to satisfy the mortgage that Joseph C. Albertson had taken out on the property.[40] In July, it was announced that the farm would be sold at auction on October 14, 1850, at the home of Henry Jennings in Southold.[41] At the auction, James Wickham purchased the property. It was where he and his wife, Frances, were to spend the rest of their lives.[42]

It appears as though the couple did not move into their new residence until late 1851 or early 1852. The farm was located just under a mile from James Wickham's parents' homestead and was situated on a prime piece of land. It was coincidently located on the eastern edge of his ancestor Parker Wickham's lost farm, the area known during colonial times as Broad Field. The property was bordered on the east by the farm of Henry L. Fleet and on the west by the lumberyard of A.B. Tuthill and O.T. Goldsmith. Along the road directly to the north, a series of houses were occupied by neighbors S. Rice, Joseph Corwin Ira B. Tuthill and widows Tuthill and Nickelson.

The property that James Wickham had acquired consisted of eighty-five acres that stretched from Main Road south to a small inlet off Peconic Bay. Unlike the other homes on Main Road, the residence was located down

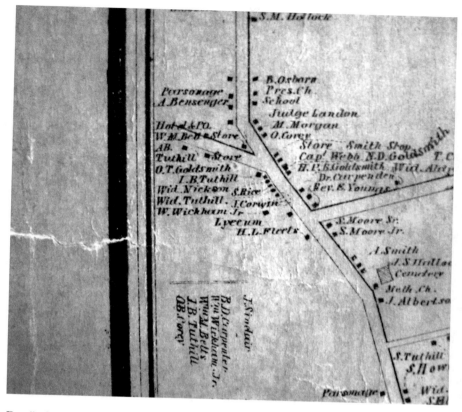

Detail of 1858 Chace map showing the hamlet of Cutchogue. The house marked "W. Wickham Jr." is the former home of Frances and James Wickham. *Courtesy of Southold Historical Society.*

a long driveway away from the road and was surrounded by fields. The building was described as a typical wood-framed two-story center hall farmhouse. Like most of the homesteads built in the area, when the building was expanded, a new, larger two-story home was added onto the western side of the original one-and-a-half-story house. The original building was then converted into a kitchen wing with a milk shed situated in front.[43]

The farm's entrance was located just east of the intersection with the road leading to New Suffolk along the south side of Main Road. It was sandwiched between the home of J. Corwin, the lyceum and the opulent farmhouse of Henry L. Fleet. By all accounts, it was a prosperous enterprise, consisting of not only a house but also a barn, milk shed and other outbuildings.

Chapter 2
NICHOLAS BEHAN AND ELLEN HOLLAND

A t the beginning of the nineteenth century, the agricultural situation of Ireland was very different than that of the United States, and thousands of Catholic families in Ireland were surviving on farms as small as half an acre.[44] The reason this was possible was due to the acceptance of the potato by the Irish farmers. Potatoes are native to the Andean highlands of South America and so highly nutritious that an acre and a half of the average white potato with some milk could "keep a family hearty for a year."[45] When the potato was first introduced to Europe, it was considered a novelty. It took nearly a century for the potato to be considered fit food for peasants and laborers.[46] Grounded into poverty by the policies of the British government, the majority of the Irish farmers struggled to practice subsistence farming. By the 1700s, the Irish had adopted the potato and were growing it almost to the exclusion of everything else. It was estimated that the average Irish person ate up to ten pounds of potatoes daily and very little else.[47]

In 1846, disaster struck when the potato crop was struck with a blight that withered the crop. Millions who depended on the harvest starved. Those who were thrown off their farms for non-payment of rent began a mass exodus to the United States and Canada that lasted for five years. Between 1846 and 1851, the potato crop failed again and again. Millions of Irish farm families had to choose between starving to death or using the money they had saved up to buy passage on a ship to immigrate to the New World. It wasn't until 1847, a year into the blight, that the Americans began to send food relief supplies to Ireland and the British government

began to set up charity soup kitchens in some of the larger cities to assist blight victims.[48]

The man accused of the murders of Frances and James Wickham, Nicholas Behan, was not a particularly memorable fellow. Were it not for the acts he was accused of, his name would have disappeared into the fog of history without any particular notice. Few if any would have wanted to know the color of his eyes or that his dark hair had a tendency to curl. However, once he was an accused murderer, everyone was interested in this man, and many publications at the time attempted to describe him for the public. One regional newspaper, the *New York Herald*, offered the following description of Behan:

> *A little above the medium height…about twenty years of age and very strongly built. There was nothing in the expression of his face, which, at first glance, would strike one as unfavorable but did not improve on very close observation. His eyes, which were dark brown or black, were deep set and had a peculiar, sinister look; and his forehead, though high, was so remarkably broad at the base as to attract attention.*[49]

Another paper, the *Sag Harbor Corrector*, offered this description shortly after the murders: "He is described as being six feet in height, broad shoulders, black eyes, and black hair inclined to curl, high cheek bones, and a fast rolling walk; chews tobacco freely, and is in about the twenty-eighth year of his age."[50] They revised their description to a much more negative one a few days later: "He stands six feet one inch in height, broad shoulders, long arms, dark sunken eyes, low forehead and exhibits an expression of countenance similar to the African race."[51]

Other than these unfair and ethnically biased descriptions of the man, what is really known of Behan? Like so many other people of Irish descent, Behan was looking for a better life in America. His tale is not unlike hundreds of thousands of others. Irish immigrants came to America—and especially New York—in such numbers that the local populace could not help but feel overwhelmed. In many instances, this led to a virulent form of hatred and racism that was seen more commonly in southern states than here in the North. There were numerous political cartoons published during the nineteenth century concerning the subject of Irish immigration, including those drawn by noted German-American illustrator Thomas Nast (1840–1902). Nast, who was known for his famous portrayal of Santa Claus, was also well known for cartoons that portrayed the Irish Catholics and Catholic

Church leaders in hostile terms. In 1871, one of his works, titled "The American River Ganges," portrayed Catholic bishops as crocodiles waiting to attack American schoolchildren; the bishops wanted to have Catholic schools for Catholic children. Nast expressed his feelings about ethnic Irish in his depictions of the Irish as violent drunks.[52]

The feeling was not very different on eastern Long Island, where many Irish Catholics were forced to buy land in secret to establish churches. In a number of local villages and hamlets, land had to be sold through a third party and then to church leaders as to avoid complaints from local Protestants.[53] On the North Fork, summer residents like the Stephenson family had strong feelings regarding the Irish. In a letter written during the late summer of 1851, Mrs. Mark Stephenson penned the following to her son William regarding a lecture given by a "Professor Roberson" in which he noted the achievements made by the United States with the help of its Irish residents:

There never was a greater blight befell any country than Irish immigration. They are the locusts of Egypt [and] they arrive by the thousands. Our poor houses are overflowing (although they enlarge them every year) and our taxes are enormous. These are the patriots our country abounds with, whose ignorance, barbarism and dirt has passed into a proverb. As great, noble, and intelligent as he has endeavored to portray the Irish character, I feel thankful that not a drop of blood of the Celtic race flows through my veins.[54]

And it was into this environment that Nicholas Behan would arrive.

Nicholas Behan, one of five children (he had two brothers and two sisters who remained in Ireland with his parents), was born in Ireland about 1830 and came to America in 1851.[55] Exactly where he was raised in Ireland is unclear; however, by the year in question, he had traveled to Liverpool, England, one of the largest ports in Europe and a center for immigration to America. He booked passage on the ship *Constellation* just a few weeks before Mrs. Stephenson wrote the letter mentioned above.[56]

The "immigrant ships" like the *Constellation* brought hundreds of thousands of foreign-born people to the United States. They were the backbone of a profitable industry. The *Constellation* was nearly brand new when it arrived in New York in 1851 from Liverpool, having been built in 1849 "by Jacob A. Westervelt and William Mackey for Robert Kermit's Red Star Line of sailing packets between New York and Liverpool."[57] The ship could accommodate

eight to nine hundred passengers in a crossing and was, at the time, "the largest sailing vessel in the New York-Liverpool packet service."[58] Behan climbed aboard the *Constellation* in the late summer of 1851 to begin his trip to New York.[59]

On average, the trip across the Atlantic Ocean took forty-three days by ship, with living conditions being somewhat primitive.[60] Most passengers— contrary to popular belief—were not always destitute or extremely poor but had to methodically save enough of their incomes over many years to afford the trip to the United States.[61] According to one author, "it often cost the equivalent of over one-third a laborer's annual income to bring an average-sized family to America" during the mid-nineteenth century.[62] Nicholas Behan arrived in New York City, not much worse for wear, on Friday, September 5, 1851, just a few days before New York businessmen Jarvis Raymond and George Jones launched their new Manhattan newspaper the *New York Daily Times*, better know today as the *New York Times*.[63]

Upon Behan's arrival, he would have been brought to Castle Garden, a former fort and public gathering place located in lower Manhattan that had been converted into "the nation's first immigrant landing station."[64] Set up to control the flow of immigrants into New York City and destinations beyond, Castle Garden became a centralized location that included "a money exchange, a labor bureau, a restaurant, the city baggage delivery, a railroad ticket office, telegraph services, boardinghouse keepers, and missionaries."[65] It was here that immigrants like Behan

> reported their names and destinations. Government officials informed them that in Castle Garden they could purchase train tickets, exchange money, seek out directions, learn about employment opportunities, and use other services. Emigrants could also sleep on the floor there for a couple of nights until they got their bearings. These services were provided partly in an effort to shield the immigrants from the thieves and opportunists who hung around the harbor waiting to prey upon the ill-informed and sometimes desperate people that flowed into the country. Also, exams given at Castle Garden served as a way to screen people and prevent those with contagious diseases from entering the country.[66]

As was the case with many other Irish men, Behan was listed as a "laborer" or "workman" in the passenger lists mentioning his arrival. This was not uncommon, as so many unskilled workers were pouring into the country during the height of immigration. New York City was constantly

expanding, providing work for many but not all who arrived there. However, the best jobs were not available to newly arrived immigrants like Behan, who often came upon signs advertising positions that included the line "No Irish Need Apply." Just a few years after Behan's arrival, New York City had over 200,000 residents who could claim Irish ancestry.[67]

Nicholas Behan was not all alone in America; his aunt and uncle resided on Thirteenth Street between Avenues A and B, though it is unclear how much contact he had with them.[68] His first recorded job was not in the city but just across the water in New Jersey, where he was employed in a brickyard.[69] After working there, he took another job, this time back in the city, where he remained until moving on to Cutchogue.[70]

Though Behan could have stayed in the city, he eventually chose to leave. This was not unusual, as the continuing flood of Irish immigrants forced wages down and led to unhealthy and unsafe living arrangements. The Irish were often forced to live in basements and other less-than-ideal locations. Overcrowded tenements, unclean water and grave sanitary conditions led to regular outbreaks of disease, especially cholera, which had arrived in the United States and New York City in epidemic proportions during the summer of 1849.[71] No one was immune, and this epidemic claimed tens of thousands of lives, including that of the former president of the United States James Knox Polk (1795–1849).[72]

Behan's move out to Long Island probably started with his registration at the Emigrant Labor Exchange, which was part of Castle Garden and was located at Twenty-seven Canal Street in lower Manhattan.[73] Run by J.P. Fagan, Esquire, its purpose was to place recent immigrants in suitable positions, often in the country. The exchange advertised in New York metropolitan newspapers, in which they noted "Farmers, contractors, and housekeepers in want of male or female laborers would do well to call at the Emigrant Labor Exchange."[74] The *New York Times* reported, "We are informed by the superintendent [of the Exchange] that no less than 10,000 immigrants of both sexes have been furnished with situations in country towns since January 1852."[75] In addition to the exchange, a number of Irish societies were established that sponsored events and meetings to support the housing, employment and political aspirations of Irish immigrants.[76] American historian John T. Ridge writes:

> *Long before the American Revolution, Irish immigrants came together to form societies to allow a bit of the Old World to survive in the new. At first, these groups were largely the domain of the prosperous middle and*

upper classes that emerged in coastal cities north and south, such as Boston, New York, Philadelphia, Charleston, and Savannah, but as the mid-19th century approached, the fever for organizing spread to all classes, resulting in the formation of hundreds of local Irish societies in large cities and small towns across America.[77]

Behan's move out to Long Island began when James Wickham, a retired businessman with a large farm located there, offered to hire him based on his registration at the Emigrant Labor Exchange. Behan was not the first to consider a move to Long Island. By 1850, just a year before his arrival, there were already many Irish (and German) immigrants who had begun to settle on the twin forks of eastern Long Island.[78] The majority first arrived there to work on the construction and grading of the Long Island Rail Road, which was extended to the whaling village of Greenport in 1844.[79] While many were working as farm laborers or servants in upper-middle-class households, their populations would continue to grow over the coming years.

Traveling to the area was fairly easy by the time Behan arrived. The Long Island Rail Road provided access from Brooklyn to much of eastern Long Island by the 1850s.[80] In addition, regular ferry service between New York City and various wharves located along the bay side of the North Fork also provided an easy route. For around $2.00, one could make the trip from Brooklyn to Greenport in just three and a half hours, shaving off days of what used to be a multi-day trip by coach.[81] Just a few years later, the same fare had dropped to $1.75.[82]

The town of Southold, which makes up the majority of the North Fork of eastern Long Island, was full of merchants and businessmen who had a great number of connections to New York City, which was often hungry for its fine produce and plentiful fish. Though the Long Island Rail Road had arrived in 1844, it was not until 1845 that trains began stopping in the hamlet of Cutchogue, located between Mattituck and Peconic.[83] It was to Cutchogue that Nicholas Behan chose to come, accepting the offer of Mr. Wickham in the early part of 1852.[84]

Behan's arrival in Cutchogue would not have gone unnoticed, as what remained of his accent would have given him away to almost anyone he spoke with. However, his height and "strongly built" physique would have gotten positive attention from local farmers (as well as perhaps some of the local ladies), who were always in need of good, stout men to work the fields. In the end, prominent resident and businessman James Wickham probably

decided he had found a bargain in hiring a man like Behan to work the grounds of his farm in Cutchogue. It would be a decision that all involved would come to regret.

Depending on how you look at it, Ellen Holland was either the catalyst of a situation that led to the death of Frances and James Wickham or she was simply an excuse that Nicholas Behan used to attempt to justify his actions. Yet while she is widely given as the reason for the crime that Nicholas Behan committed, no one has spoken about who she was. The story of Holland's life began the same way as Nicholas Behan's and more than half a million other Irish immigrants.

Ellen Holland was born around 1819 in County Monaghan in the northeast of Ireland. Prior to 1860, there were no records kept on the births or deaths of the Catholic population. Her early life and family history is unrecorded. In fact, Holland herself wasn't sure how old she really was because she didn't know when she was born.[85] She probably belonged to one of the many Catholic farm families of the area. The County of Monaghan, which boasted a population of 200,442 in 1841, had dropped 29 percent to 141,823 by 1851.[86]

Holland survived four years of the famine in Ireland until 1850, when she had saved enough money to purchase passage on a ship bound for New York. She had the choice of continuing to starve at home or chancing the trip to the United States in hopes of a better life. Her choices for transport to a new life ranged from new ships like the one Nicholas Behan took to hastily converted trade and slave ships, which flocked to Ireland to accommodate the flood of people clamoring to leave.

In 1851, she booked passage on the ship *Robert Parker*. The *Robert Parker* had begun its sailing career from Portsmouth, New Hampshire, before 1840 as a packet ship that advertised space for a few cabin passengers as well as some steerage accommodations. By the time Holland had booked her trip, the ship had made the crossing between the old and new world more than a hundred times. Normally traveling between Liverpool or LeHavre, the *Robert Parker* would arrive at a number of ports up and down the East Coast of the United States during its voyages.[87] Undoubtedly, the passage was less expensive than some of the newer ships available to immigrants.

Like many young women at the time, Ellen Holland was not traveling alone. A woman alone was a target for unwelcomed attention from men. Society demanded that a decent woman always travel with a male family member or, if one was not available, at least one other woman. Holland is listed on the manifest as traveling with her older brother Thomas Holland.[88]

Once in the United States, it was imperative that the newcomers find work as soon as possible. Having arrived in September with little or no financial resources, Ellen Holland, like Nicholas Behan, would have probably turned to the Emigrant Labor Exchange for job placement. With no education, opportunities would have been very limited. She would have been able to get a job as either a domestic servant or a factory worker. Being a servant in England was very different from being one in America. As a domestic in Ireland, Holland would have been part of a very stratified society. The average upper-class household would have had a hierarchy of servants headed by a butler and/or housekeeper, and each serving position would have had a set job description. Interaction between the employers and the domestics would have been very limited. The most elite jobs in upper-class households required knowledge that a girl like Ellen Holland would have had no opportunity to possess.[89] Servants in England would have associated with each other but not with their employers. They were considered a household convenience, not part of a family unit.[90]

In the more relaxed society of the United States, household servants had become a middle-class status symbol. Servants were generally considered to be part of the family unit, and their behavior was overseen by the employer. In fact, New York State held that employers were legally responsible for the behavior of their employees if they lived with the family.[91] Along with a salary, most serving positions included room and board. Domestic servants and farmhands commonly lived in the same house with the families that employed them, ate meals with the family and worked alongside them. The head of the household would have had a patriarchal role, and society granted and expected him to use his authority to control the behavior of all of his dependents, including any servants in the household. While being a servant to a wealthy family in the city might have been outside the experience of a poor farm girl, serving on a farm in the country would not have been much different than family life on a farm.

Shortly after her arrival in the United States, in December 1851, Ellen Holland traveled to Cutchogue to start work at her first job.[92] Her new employers, Frances and James Wickham, hired her to work as a domestic servant on their farm. Holland's brother Thomas did not travel with her to Suffolk County but instead remained in New York City and worked as a laborer.[93]

Chapter 3

THE DISMISSAL

After moving into their new home in Cutchogue in late 1851/early 1852, Frances and James Wickham set about gathering a staff to help them successfully manage the house and farm. Eighty-five acres of farmland required the labor of several men. In 1848, James Wickham hired an eight-year-old African-American boy, Stephen Winston, to help out around the house. By 1851, Winston was eleven and still not quite old enough to help with all the heavy work of a farm, so Wickham hired Nicholas Behan. In the house, Frances Wickham had the help of Ellen Holland, who came to the farm in December 1851, and Catherine Dowd, who was also from Ireland and joined the Wickhams eight months later in August of 1852.[94] There may have been some adjustment on the part of the Irish immigrants to the different social structures in the Northeast of United States.[95]

For the first year, all was well on the farm. James and Frances Wickham had been married for four years and were well known and respected in the community. The farm, which was a very different enterprise from running a store, appeared to prosper. Wickham had experience from helping on his father's farm when he was growing up and the support of his family in town to help make the right agricultural decisions.

In the beginning of 1854, Frances and James Wickham would have seen themselves as the patriarchal authority of the household, even though most of their workers were already adults. Everyone in the household, with the exception of Winston, who was fourteen, would have been considered a grownup.[96] Catherine Dowd was about twenty-four, Ellen Holland was between twenty-five and thirty-one, Nicholas Behan

Wickham House, circa 1935. This is the house that Frances and James Wickham purchased from the estate of Joseph C. Albertson in the fall of 1850. *Courtesy of Gekee and Thomas Wickham.*

was twenty-four, Frances Wickham was thirty-three and James was the oldest at age fifty.[97] Ensuring that the unmarried individuals in their care maintained a respectable reputation would have been an unspoken priority in the average American household, and certainly in the Wickhams' home. The Wickhams would have also felt justified in directing their employees' interpersonal relationships if necessary.[98]

As was typical at the time, all of the staff lived in the house with the Wickhams. Ellen Holland and Catherine Dowd shared a room in the attic of the main house directly above the Wickhams' bedroom. The stairs to the third-floor attic space were situated around the corner and down the hallway from the Wickhams' room. Frances and James Wickham had their bedroom on the second floor overlooking the waters of the bay. Nicholas Behan probably had a room on the second floor of the kitchen, along with the bedroom of Stephen Winston. Most kitchens during the time period were located in wings off the main section of the house. The separation of unmarried individuals to distant ends of the building and the rooms of the married couples in between helped to maintain a respectable reputation for all members of the household.

Nicholas Behan, who was apparently a good worker, started courting Ellen Holland in late 1853 or early 1854 and had been giving her small

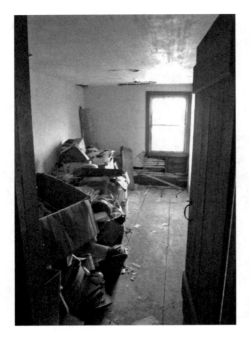

The attic room of Ellen Holland and Catherine Dowd. James Wickham plastered and finished off the space for the servant girls when they came to live in Cutchogue. *Authors' image.*

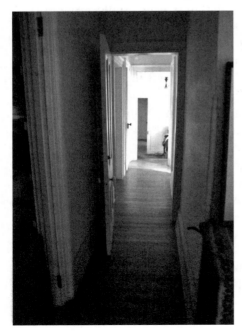

The upstairs hallway that accessed the Wickhams' bedroom and Stephen Winston's bedroom. His was the lighted room at the end of the darkened hallway. *Authors' image.*

presents. Holland apparently did not return his admiration, although she accepted and kept the gifts. At some point during the week of May 20, 1854, she must have mentioned to Frances Wickham that she did not reciprocate Behan's affection. The household was about to learn that the neighborhood rumors that Nicholas Behan had an ugly temper were true.

As would any employer at the time period, Frances Wickham acted on Holland's complaint that Behan was continuing to court her against her wishes. Apparently, she informed Nicholas Behan that his attentions were unwanted and that he was to leave Holland alone. Behan did not take the instruction well. But Mrs. Wickham did not tell her husband about the looming situation, probably confident that as the boss's wife she had full authority needed to handle the incident.

By all accounts, Behan was a man with a great deal of pride and a passionate temperament. He was probably offended at having Frances Wickham interfere in his courtship for two reasons. First, his employer's wife was interfering with his personal life, as if he was a child. Second, as a woman, she

was of a lower status than a man, and he may have felt that women had no place in directing a man—even if he was working for her husband. This attitude toward women was common prior to the suffragette movement, when women had few rights. That week, Nicholas Behan tried to persuade Ellen Holland to meet him alone out on the road away from the house. Holland refused, saying that she would meet him on the north stoop and that if he had anything to say to her he could do it at the house.[99]

Part of spring-cleaning on a farm is the airing and restuffing of all the mattresses in the house.[100] But carrying a heavy mattress in and out of a house is too much work for most women, even when working as a group. On Saturday, May 27, 1854, Frances Wickham decided it was time to restuff the mattresses in the house. James Wickham had gone to New York City on business and wasn't going to be back until either that evening or the next morning. Nicholas Behan was instructed to carry all of the mattresses out of and back into the house. He took the opportunity to make known his displeasure at Mrs. Wickham's stance on his personal life by using a mattress to slam her hard against a door. The blow was hard enough that Frances Wickham hurt her side. Holland later said that she thought that Behan's mood that week had been ugly toward Mrs. Wickham.[101]

Frances Wickham was alone in the house with two young women, a young boy and a very angry man. She was shaken enough at the incident with the mattress that she now knew that Nicholas Behan indeed had an ugly violent temper and that his ire was now directed at her. Instead of sleeping in her own room that night, she changed bedrooms after Behan had retired for the night, perhaps fearing further reprisals.[102]

The next day, when James Wickham got home, Frances told him about Nicholas Behan and Ellen Holland and about the mattress incident. Wickham scolded his wife for not telling him immediately about the relationship between the two servants. He then, with William Betts as a witness, found Behan and told him that he was going to let him go from his job because he did not want any disturbances in his family. Since Behan had a debt at the local store, which also would have served as the local bar, James Wickham paid storekeeper William Betts the ten dollars that Behan owed. He then gave Nicholas Behan two dollars, enough to pay for a train ticket to Brooklyn, which was the western end of the line of the Long Island Rail Road and closest to New York City. In the city, Behan would have a wider range of job opportunities than on the east end, and he would be far away from Cutchogue. Wickham didn't feel that he owed Behan the money for the train ticket but wanted to give it to him anyway.[103] Remarkably, Behan did

not make a fuss and left the farm. Later that day, Ellen Holland realized that the thirty dollars she had saved in a trunk in her room was missing.

Behan did not go very far. When he left James Wickham's farm, he walked west down the Main Road to William Wickham Sr.'s farm. There he spent the night with the other farmhands. The next morning, Wednesday, May 31, he got up and had breakfast with James's father and told him about losing his job because of his courtship of Ellen Holland.[104] Later that day, Behan went back to the Wickhams' farm. He found Mr. Wickham and asked for his job back. Wickham refused. Behan then demanded that Wickham give him a horse. James again refused Behan's demands, stating that Nicholas was cruel to horses. During the conversation, he asked Nicholas if he had anything to do with Ellen's missing money. Nicholas admitted that he took the money but justified the theft, stating that he was getting his money back for all the presents he gave Ellen. Wickham replied that stealing money was a state offense and that he could be put in prison for taking the money but then dropped the matter. Behan left empty-handed and returned to William Wickham's farm to again spend the night.

On Thursday, June 1, Behan came back to the farm yet again with a man named Florence "Flore" McCarthy, whom he had met about six months earlier while working for William Wickham Sr.[105] He was there to pick up the rest of his belongings, namely his trunk. Behan and McCarthy carried the trunk up the driveway and over to William Betts's store. Another acquaintance, John Delany, helped him carry his trunk over to the depot the following day so that Behan could catch the next train to Greenport. Delany said that Behan "threatened in my hearing that he wanted [to] have revenge upon Ellen Holland. Nicholas said in so many words that he intended to ravish Ellen Holland."[106]

Chapter 4
THE MURDER

The incident that sparked the dismissal of Nicholas Behan from the service of James Wickham in 1854 is one that would probably require a simple "slap-on-the-wrist" warning in today's culture. But at the time it occurred, that kind of infraction was considered intolerable and unbecoming of a moral, ethical person. On the other hand, Behan's reaction to his dismissal and the events that came to unfold shortly after it happened were, by any standard, an extreme, unprovoked and violent response. The action that Behan took would place his name forever in the annals of local history and came to confirm the worst fears and assumptions regarding the Irish in America.

The late spring of 1854 was like many that had come and gone before. Farmers were preparing fields for planting and fertilizing. Bunker fishermen were out hauling in huge seining nets, catching menhaden by the hundreds of thousands to be loaded into farm wagons and then taken to local farms so the oily fish could be plowed into the earth to fertilize the fields. The smell of the decomposing fish washed over the landscape for miles, leaving few to wonder what time of year it was.

Friday, June 2, brought the end of a long, busy week for most business owners, who were completing deliveries of goods for local stores while the chatter of gossip of the upcoming weekend's activities were discussed in local shops. Nationally, the debate over the Kansas-Nebraska Act was over, and the bill had become the law of the land, allowing the western territories of the United States to determine through popular vote whether they would

allow slavery or not.[107] Locally, it was a time of prosperity on Long Island's North Fork. In the hamlet of Southold Town, local nursery owner and community philanthropist Israel Peck was busy building and decorating his mansion, named Spruce Park, on the south side of Main Road.[108]

At a farm like the one owned by James Wickham in Cutchogue, work began early. Servants woke before dawn to begin their chores and to prepare the house for the day. Fires were lit, and they began prepping food for both staff and their employers. Chickens were fed, horses were hooked up to plows and other workday activities were done during the day. At midday, farm workers met to eat their largest meal of the day and then headed back out to the fields. Housemaids continued prepping food for the formal evening meal that would be served to their employers and completed other household tasks. During the evening, workers enjoyed a light supper, smoked pipes and talked of the day's activities. Most retired early to get a good night's sleep before tomorrow's toiling. Following a fine meal, the men and women of the house retired to their separate parlors to read and discuss the day's news before turning in for the evening. Last to go to bed were the housemaids, who finished cleaning and extinguishing candles, lamps and fires before they went to their rooms for the evening. It should have ended like any other day, but unfortunately, it wouldn't. For the Wickhams and Ellen Holland, Behan's

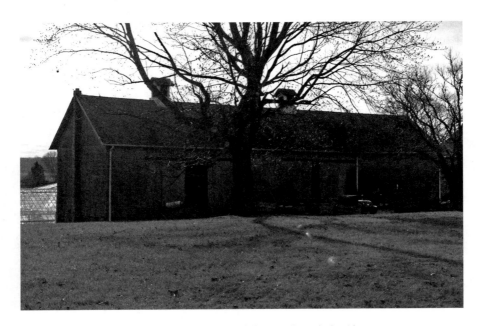

The Wickham barn, which dates to the time of the murders. *Authors' image.*

departure from the farm must have seemed to be the conclusion of their problems, but in fact, it was only the beginning.

Exactly how long Behan had been planning to return to the farm to punish and take revenge on those that had cost him his job is unknown. Clearly, he was very angry, perhaps angrier than he had ever been before in his life—so angry that he appears to have planned an attack that would deliver a severe penalty to the Wickhams the likes of which had not been seen in Cutchogue since the days of the American Revolution.

After all had retired for the evening, Nicholas Behan returned to the Wickham farm, close to midnight, when he could be sure everyone was fast asleep. When he arrived, he had to arm himself. Being familiar with the farm, he had many choices—a shovel, a scythe, a piece of wood—almost anything could be found among the supplies that were readily available. Instead, he grabbed a post ax. The post ax, also called mortise ax, was a common item on most farms of the period and was used to cut mortise holes and "employed in completing fence hole posts."[109] Its long and narrow bitted head and long handle made it ideal for both the work it was designed for and for the job that Behan had in mind.

The Wickham home had been reasonably secured by the time of his arrival, so Behan had to find a way into the house that would not alert those resting inside. He probably remembered that the kitchen window was rarely locked; after all, he had passed by it day after day for two years. The ladies

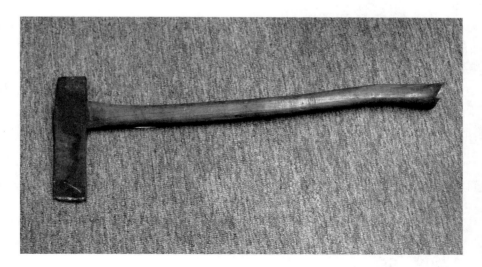

The post ax used to attack Stephen Winston and to murder James and Frances Wickham. *Courtesy of Suffolk County Historical Society.*

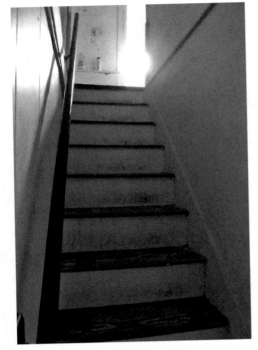

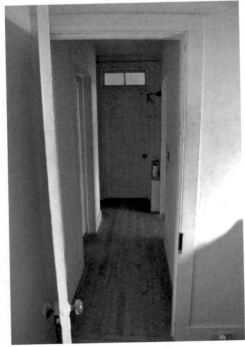

who worked in the kitchen were often desperate for a little breeze to cool them down this time of year—why would today have been any different? He removed his shoes and tried the window, and after a little careful effort, it slowly slid open.[110] To avoid detection, he would have to be careful going through the window. There was no telling what kitchen implement or bowl might be in just the wrong position for him to hit as he climbed into the room. One wrong move and all would be alerted to his presence. And what about the dog? The Wickhams were known to have a very dutiful dog that slept in the kitchen—would it alert the household? No. The dog knew Behan well, and as it greeted him, Behan removed his straw hat and gently placed it on the furnace in the sink room.[111] A little treat would keep him quiet as he prepared to move up the servants' stairs to the second-floor bedroom above the kitchen. It was here that Stephen Winston

Top: The back staircase located in the kitchen wing of the Wickham house, where Behan ascended to attack Stephen Winston. *Authors' image.*

Left: Second-floor kitchen wing hallway of the Wickham house. It is down this hall that Nicholas Behan crept as he prepared his initial attack on Stephen Winston. *Authors' image.*

slept. Stephen had come to work for Mr. Wickham from New York City, where his mother, Susan, and seven siblings resided in the Fifth Ward.[112] Stephen's mother, who had been born in Virginia, came to New York for a better life than the one she and her family faced in the South. Stephen may have been indentured to the Wickhams so that he could learn a trade that would serve him well later in life. Life on a rural farm was certainly better than living in the city. Or at least it should have been.

Behan knew Winston well enough that he would certainly alert the rest of the household to his presence. He could not afford that. He crept up the stairs as quietly as possible. A door secured by a rope allowed access from Winston's room to the hall in front of Mr. and Mrs. Wickhams' bedroom. A few cries would alert everyone. Behan could see the boy, who was sleeping quietly across the room. As he approached, he raised his arm and swung hard. He struck the boy several times on the head, leaving him incapacitated and unable to move.[113] Blood spattered everywhere and traveled down the handle of the axe all over Behan's hands.

With the silencing of young Stephen Winston achieved, Behan opened the door that separated the kitchen wing from the main part of the house. As he slowly opened the door, Behan expected to find his prey asleep, making his job an easy one. To his surprise, he was confronted by Mrs. Wickham, who was startled by his presence. The Wickhams told him that he had no business there, and that he should take what he wanted and leave.[114] They then moved into the hall in show of force, which only enraged Behan further. He pushed both Mr. and Mrs. Wickham back into their bedroom and struck James Wickham with his ax. As one newspaper reported, "Here the deadly contest took place between the murderer and his victims."[115]

Mrs. Wickham is said to have yelled out to Behan, "Nicholas, don't kill him! Don't kill him! Take what you want in the house, but don't kill him!"[116] Her pleas would land on unsympathetic ears. Behan struck James Wickham with such ferocity and speed that the attack quickly resulted in at least twenty wounds to the poor man.[117] He crumpled to the floor, with his head facing the doorway to the bedroom. Mrs. Wickham, seeing no alternative, tried to escape through one of the windows, but Behan grabbed her and dragged her across the floor to keep her from causing any further alarm.[118] He then took the bloodied ax and struck her twice in the head. So hard were the blows that her skull was shattered, causing blood and brain matter to be spewed around the room.[119] She too fell to the floor with her head facing the window, and all went silent.

The screams and sounds coming from below awoke the two servant girls, Ellen Holland and Catherine Dowd, who slept in a shared room in the attic

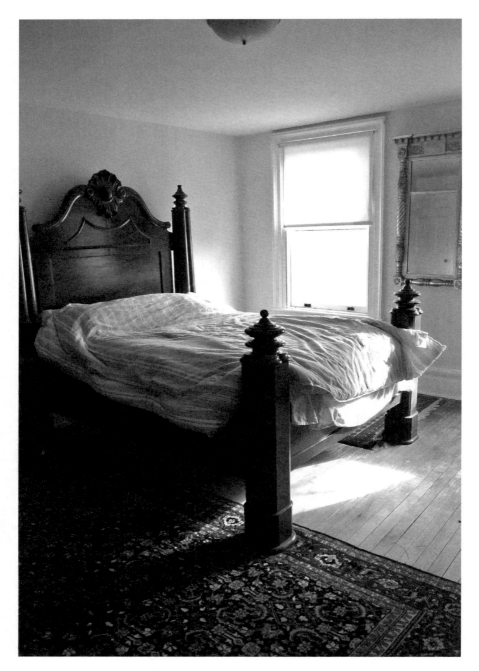

One of the large bedrooms on the second floor of the Wickham home. A mirror of the actual bedroom where the murders took place, this bedroom is furnished to the period of Frances and James Wickhams' residency. *Authors' image*.

of the house. Ellen Holland, whose relationship to Behan had led to the nights' events, was certain that Nicholas was involved whatever was going on downstairs.[120] As there was no way down without alerting Behan, the girls decided to exit their room through a window that led to the roof of the kitchen wing. Catherine Dowd was the first onto the roof, followed shortly thereafter by Ellen Holland. Dowd climbed onto the roof of the milk house, which was attached to the kitchen, landed on the ground and headed for the home of the Wickhams' neighbor William M. Betts.[121]

Behan looked over his deed with satisfaction, but his work was not done. He exited the room and tied off the door between the kitchen wing and the main house to a nearby rafter, ensuring that no one could follow him.[122] He then descended through the house and climbed the main staircase to the attic, where he hoped to find Ellen Holland and her companion Catherine Dowd asleep. When he arrived, he found that the two women were gone and the window open to the kitchen roof.[123] Panic probably ensued. Behan had planned to kill everyone and get away without punishment, but soon, it seemed, others would be alerted to the gruesome events of the evening. He tried to exit the house but became lost in the dark and ended up back in the Wickhams' bedroom. With no alternative, Behan dropped the ax out of their bedroom window and then lowered himself to the ground below, where he set off on foot, leaving behind bloody stains on the windowsill.[124]

The servant girl Catherine Dowd was rapidly approaching the home of Mr. Betts, who lived not far from the Wickham home. William M. Betts was a native New Yorker and a successful merchant in Cutchogue, where he was a

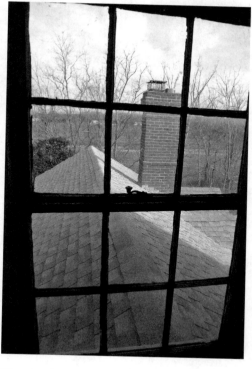

The view out of the attic window, through which the girls climbed to escape Behan's wrath. *Authors' image.*

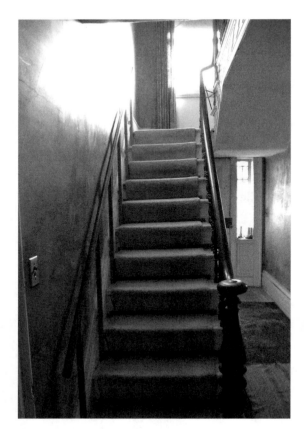

Left: The main staircase of the Wickham house, which Behan climbed to get to the bedroom of Holland and Dowd. *Authors' image*.

Below: The former clover fields that stretched from the house to Main Road, across which Catherine Dowd fled to William Betts's hotel. *Authors' image*.

longtime member and pew holder at the Presbyterian Church.[125] Dowd's screaming woke Betts, who attempted to find out what was going on. Dowd supposedly yelled, "For God's sake, go to our house, for murder is being committed!"[126] Betts thought the girl was crazy and did not at first listen to her. Soon though, as she continued to persist, he decided something must be wrong.

Betts dressed himself, woke his son and went to call on two of his neighbors, Dr. Benjamin Carpenter and Silas Carpenter.[127] They met up with Thomas Raynor, Hull Webb and local mason Joseph Corwin, who had been roused by Ellen Holland not long before to elicit their support.[128] The group walked to the Wickham home, surrounded it and listened for a sign of any intruders. They then moved closer to the house, where they began to hear faint groaning noises coming from an open window on the second floor.[129] They attempted to enter the house but found the doors locked, at which point they broke down the kitchen door, found a lamp, lit it and ascended the main staircase. As they entered the Wickhams' bedroom, they discovered a gruesome scene.[130]

The room was said to resemble the interior of a slaughterhouse, with skull fragments, splashes of blood and brain matter strewn around the room. As the doctor entered the room, the mortally wounded James Wickham tried to rise on his hands and knees, crying out "Oh my! Oh dear!" before collapsing again onto the floor.[131] After quickly assessing James Wickham, the doctor approached his neighbor's wife and found her in even worse shape from the blows that had struck her head. Mrs. Wickham's skull had been penetrated by vicious blows that caused a large portion of brain matter to be thrown upon the floor.[132] The doctor returned to James Wickham, had him lifted onto his bed and began treating him. The man had numerous wounds, a jaw broken in multiple places and a skull that was crushed on both sides behind the ears.[133]

A further search of the house led to the discovery of the badly injured Stephen Winston, who had done no more than work in the Wickham house to earn his fate. He was "dreadfully injured in the head, having received… three blows," one of which removed one of his ears and another that badly fractured his skull.[134]

Now the hunt was on for the perpetrator of these vicious crimes.

THE HUNT FOR BEHAN

The night of June 2, 1854, must have seemed surreal to the residents of Cutchogue. Normally, the community would be nearly silent, save for the sounds of a breeze moving through the trees or the sounds of crickets and other wildlife piercing the quiet. The darkness was pervasive, and except for a clear night when the moon would light up the sky, it would be hard to see beyond just a few feet in front of oneself. Tonight, however, was different.

At the Wickham homestead, everything humanly possible was being done for the victims. They were placed onto the bed while the caregivers determined what course of treatment would be next. Dr. Carpenter, a young man by any standard (he was twenty-eight), probably thought he would never see such a sight in Cutchogue. He was newly married, and his first child, a son named William, had been born just three months earlier.[135] What if such a thing had happened to him, he wondered. Who would take care of his wife and young child? He had no time for such worries now, though, and he returned to his patients.

Behan himself had little time either. After he landed on the ground below the Wickhams' window, he put on his shoes and set off eastward in the darkness, passing through the fences and paddocks of the farm. He climbed over one of the fences, leaving behind bloody marks on the surface of the rails as he headed for a nearby cornfield.[136] Upon entering the field, he pushed his way farther, leaving behind a trail through the broken and misshapen stalks that would later help searchers.[137]

Dr. Carpenter continued to monitor his patients, but he realized that other than binding the wounds and trying to make them comfortable, there was little he could do. Mrs. Wickham, who was struck only a few times, was unconscious and in dire shape. She lingered without regaining consciousness until about 2:00 a.m., when she expired.[138] James Wickham continued to hold on—for the moment.

Around Cutchogue, word was spreading, and the darkness was being lifted as house after house lit up after hearing the news. Lamps and candles were lit, shutters and doors were locked and secured and men grabbed their guns and watched over their families' safety as the night wore on. Fear gripped the community, as each household wondered if they might be next on this madman's list. Sleep would have to wait, as all counted the hours and minutes til dawn.

Nicholas Behan continued east, following the railroad tracks toward Greenport, where he had taken a room since his departure from William Wickham Sr.'s farm.[139] There he would be able to find shelter and some food from other Irish residents who had a small community of shanties located near the village.[140] He would certainly be recognized at the docks if he tried to leave by boat. He would have to bide his time and carefully make his way west again toward Cutchogue if he was to escape the area undetected. That night, he stayed with the Connor family and breakfasted among them in the early morning before setting off again, this time heading west.[141]

Dawn could not have broken soon enough for the residents of Cutchogue. Word had spread of the death of Mrs. Wickham, the fragile state of Mr. Wickham and the poor African-American servant boy who clung to his life. Few could believe the horrid events of the past night.

As dawn broke, fear turned to anger and men began to organize local residents in order to capture Behan. They began to contact other families nearby. Word spread to neighboring communities to be on the watch for the suspected murderer. Word was received early in the day that Behan had been spotted in Greenport, though a thorough search did not turn him up.[142] Where was he headed? Out to sea, perhaps? The docks and ships of Greenport were turned upside down, but again, no sign of Behan.

June 3 became the longest day in Cutchogue's history, as neighbors and friends of the deceased mourned her. People continued to hold out hope for the two remaining victims, though their own doctor did not. Dr. Carpenter watched helplessly as James Wickham moved in and out of consciousness, all the while barely making any sense at all when he did come to. Time was

running out for both his patient and the ability of the community to lay their hands on Behan.

As darkness fell, Behan carefully made his way west, maneuvering five miles to the west of Greenport without being noticed over the course of nearly twelve hours. It was progress, but not enough, as everyone was now looking for him. Nearly one thousand people had joined in the search.[143] Hungry and tired, he decided to stop at the home of a Mr. Thompson, just outside the hamlet of Southold, in hopes that the man would offer him some food and drink.[144] He was also hoping that the man would not suspect his identity. John Thompson was, like Dr. Carpenter, a young husband and father, but like Behan, he was also an Irishman.[145] Behan probably had high hopes that this fellow "son of Erin" would aid him in his escape.

Meanwhile, as the stroke of eight o'clock approached, James Wickham was slipping fast. His breathing was becoming shallow and his pulse weak. Dr. Carpenter waited impatiently; there was nothing else he could do as Wickham grew weaker and weaker. He looked over the battered body of his patient, noting the bruises and scratches on his hands and arms that indicated he had given at least as good as he had gotten trying to defend against his attacker.[146] At eight o'clock, James Wickham took his last breath, and word spread that the day had claimed a second victim.[147]

As Nicholas Behan entered John Thompson's house, he asked for some food and drink, perhaps pretending to be just another fellow Irishman traveling through the community to a destination unknown.[148] John Thompson was no fool, though, and quickly became suspicious, probably tipped off by marks and bruises that Behan could not hide. He asked if he happened to be the man who had worked, until recently, at the farm of James Wickham. Sensing there was no point in trying to hide his identity any longer, he confirmed Thompson's suspicions. Thompson replied coolly, "Then you are the man that has done that murder."[149] Behan, caught off guard, replied, "Yes I am, and I have not done as much as I mean to do." Thompson moved quickly to grab his rifle and aimed it point blank at Behan. He blocked the only exit with his body and then told Behan that he should be placed under arrest.[150] Having misjudged John Thompson, Behan pulled out a pistol from his pocket and aimed it squarely at his would-be arrestor.[151] It seemed that John Thompson was about to become his fourth victim in just twenty-four hours.

Luck prevailed on Thompson, as a wagon approached his home. As it pulled up closer to the house, he threw opened the door he was blocking and yelled for help in placing Behan under arrest. The driver, a man named Silas Hallock, responded to Thompson's call to arms and tried to tie up his horse

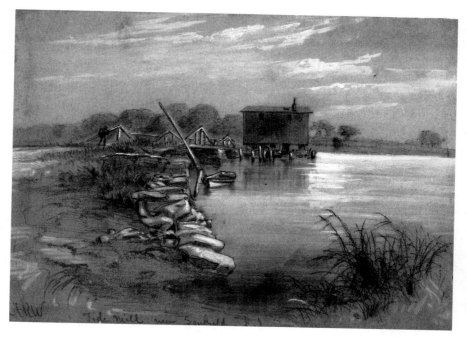

Alfred R. Waud's drawing of the Tom's Creek Mill, located between Southold and Greenport. It was here that Behan was almost captured after escaping from John Thompson's residence on Boisseau Avenue in Southold. *Private collection.*

as quickly as possible.[152] Behan, sensing his predicament, opened a nearby window and jumped through it into the ever-darkening landscape. Hallock and Thompson chased Behan through a nearby field of wheat and then into the woods before losing sight of him. The alarm was raised with neighbors, who having armed themselves with rifles, pistols and at least two dogs, began to help in the search for Nicholas Behan.[153]

Behan was now in real trouble. Though the cover of darkness would help him in eluding capture, he would have to hide out someplace if he was going to survive the night. He headed back east toward Hashamomuck Pond, a large tidal pond located between Southold and Greenport. For about an hour, he worked his way through woods and along the pond until he came back to Main Road near the Long Island Rail Road's train bridge on the edge of Tom's Creek.[154]

Groups of armed and angry residents were now searching high and low for Behan. They moved through fields of wheat and corn and searched thickets and the deeper woods hoping that he might be spotted. Darkness had fully settled over the North Fork, and it was now feared that little could

be accomplished until morning. Some of the men made their way back toward the road near the railroad bridge at Tom's Creek to decide where to go and what to do next. Then, they spotted a figure near the road. It was a man, but who? As they began to approach, the figure ran, and they knew they had their man.[155] One of the dog owners let his trusty canine loose after the man. Unfortunately for another man nearby who was also Irish, the dog mistook him for the perpetrator and quickly took hold of him until other nearby members of the party could pull him off.[156] In an instant, Behan was off and running again, and another victim had been wounded due to his actions. A few shots fired by those in pursuit missed their target, and Behan vanished into the night.[157] He had survived yet another day on the run.

Sunday, June 4, should have been a day of peace and worship across the North Fork. While most residents were either members of the Presbyterian or Methodist faiths, other small congregations of Universalists, Unitarians and Catholics were also present. But regardless of faith and the fact that "the church doors were opened," they were all united in the search for Nicholas Behan.[158] Along the railway line running from Greenport to Cutchogue, armed men were stationed with every conceivable weapon imaginable, including muskets dating back to the time of the American Revolution.[159] There was no sign of Behan.

Nicholas Behan was determined to get away, having spent the previous night lying in the woods until about eight or nine o'clock in the morning avoiding capture.[160] He had to start heading east again, as there was nowhere else to go. With the Long Island Sound to the north and Peconic Bay to the south, he had to head west; it was his only chance. He carefully moved west, eventually and with much difficulty making it past Southold, where he had encountered John Thompson just days before. Past the edge of the hamlet, he now had to get through the hamlet of Hermitage (present-day Peconic), which was located just west of Southold.[161] Again, Behan lay down for the night, this time in a nearby wooded swamp.[162]

By the morning of Monday, June 5, there still had been no sign of Behan. Men and women alike were tired, and those pursuers still on duty were exhausted. Just before 9:00 a.m., two members of one the companies of men searching for Behan, John Jones and John Jacobs, entered a swampy area located just north of the Hermitage railway station.[163] As they were searching the muck for any hint of life, Jones stumbled over something in the water. It quickly became apparent that it was a man who was nearly hidden in the one-foot-deep water. John Jacobs then grabbed hold of the man and lifted him out of the water.[164] Wounded by a self-inflicted knife cut to the

The corner of Peconic Lane and North Road looking north toward Mill Lane. It was slightly east of here that Behan made his final attempt to evade his captors. *Courtesy of Southold Historical Society.*

throat, it was soon determined that it was none other than the hunted man, Nicholas Behan.[165] Those involved in the search, "as already agreed upon, fired their pieces into the air to announce the capture."[166] Constables on the scene from New York City had to restrain the crowd from "hanging him on the spot."[167]

The local populace cheered Behan's capture, as they now had nothing left to fear. His capture was the culmination of two and a half days of surprise, sadness, anger and mourning for residents of the North Fork. With the accused carted away to Riverhead, where the county courthouse and jail were located, it was time for silent contemplation and preparation for the burial of his victims.

Behan's capture was the culmination of work done at the inquest, which had been held on June 3 just hours after the Wickhams' deaths. Coroner Wines oversaw the inquest, in which testimony was provided to jurors regarding the behavior and threats made by Nicholas Behan. In addition to the testimonies, the inquest included an examination of the murder scene as well as of the victims' bodies. Upon conclusion, a verdict was rendered by the jury that James and Frances Wickham had come to their deaths at "the hands of some person to them [the jurors] unknown" and that "they have reason to believe and are of the unanimous opinion that the injuries were inflicted by Nicholas Bien [*sic*]."[168]

THE LAWYERS

W hen Behan was finally captured, it was readily understood that there would be a trial, assuming the local authorities could keep an irate populace from lynching him outright. This was a real possibility, as one newspaper reported, "The inhabitants had turned out in a body to hunt the villain, and when they found him, they could scarcely be restrained from hanging him from a tree."[169] Behan would be taken into custody and lodged in the old jail in Riverhead, the county seat.

The trial would be like nothing seen since the last major murder trial, which had taken place thirteen years earlier in 1841.[170] Though a conviction should have been easy, the district attorney of Suffolk County faced a conflict of interest. He was William Wickham (1819–81), the brother of the murdered James Wickham. William Wickham had "received a law degree from Yale and was admitted to the bar in 1841 after getting practical training in the office of Hon. Selah B. Strong of Setauket, NY. He began to practice law in nearby Patchogue until he moved for good to Cutchogue in 1854. In 1847, 1850, 1853, and 1855, he was elected District Attorney of Suffolk County, gaining a reputation as a faithful public steward."[171] As the representative for the people, Wickham knew that he would not be able to serve as prosecutor in the death of his brother and sister-in-law. But who could replace him with the zeal necessary to secure justice? The search began for a suitable replacement.

Though William Wickham may have had input on who would serve for the prosecution, it was up to the attorney general of New York State

Portrait of William Wickham Jr. painted by Edward A. Bell, Suffolk County district attorney and brother-in-law of James Wickham. *Courtesy of John and Mary Lou Wickham.*

to ultimately make that decision. At the time of the murders, the attorney general of New York was Ogden Hoffman (1794–1856). Hoffman was the son of former Attorney General Josiah Ogden Hoffman (1776–1837), one of the original justices of the New York City Superior Court.[172] Ogden Hoffman was originally a Democrat, but following President Jackson's fight and ultimate removal of funds from the second Bank of the United States, he switched parties and joined the Whig cause. As an attorney, Hoffman was best known for his successful defense and the resulting acquittal of Richard Robinson for the murder of Mary Jewett in 1836.[173] Other lawyers knew all too well of Hoffman's abilities, with one writing that his "persuasive powers and uninterrupted success before juries became, during a quarter-century, proverbial."[174]

Hoffman was born near Goshen, in Orange County, New York, where so many second, third and fourth sons settled after the American Revolution due to the abundance and availability of land. A schoolboy companion of William Henry Seward (1801–72), Hoffman was admitted to the Orange County Bar and soon became noted for his cleverness and wit.[175] He left his profession briefly to serve in the United States Navy during the War of 1812. There he became the "cherished and favored aid of Commodore [Stephen] Decatur" aboard the U.S. frigate *Guerriere*, which aided in the defeat of the infamous Barbary pirates.[176]

Ogden Hoffman, the New York State attorney general who tried the Wickham murder case. *Collection of The New-York Historical Society, 1966.2.*

Hoffman was elected as a Whig to serve in the United States Congress in 1836, and upon the election of President William Henry Harrison in 1840, he was appointed as the United States attorney for the southern district of New York.[177] He was considered fair and evenhanded as a state prosecutor, and in his own words, he never "spelled prosecutor as persecutor."[178] It was said that his voice served him as if it were an instrument— it was something that "could impressively denounce, it could strike a pathetic tremolo, and it could lightly enunciate wit or humor, rise to an alto in sarcasm,

or attune itself to the faintest of tender tones."[179] He was simply considered one of the best attorneys of the era, worthy of having his name inscribed upon "any monument of rhetoric" that commemorated his "eloquence and forensic skill."[180] In November 1853, he was elected to serve as the twenty-fifth attorney general of New York.[181]

Hoffman had a difficult decision to make in the Wickham case. Who should he appoint as prosecutor? Would his decision be political? The case was garnering great attention in both New York City and the surrounding communities. Newspapers throughout the state would be reporting on the murders, and this could be a good way to advance both justice as well as a career. In the end, Attorney General Hoffman decided he would prosecute the alleged murder himself and appointed Alexander Hadden, Esquire (1812–66), formerly a resident of Hempstead, Long Island, as his deputy.[182]

Alexander Hadden was a well-known attorney in both Kings and Queens Counties, having served as district attorney for the latter beginning in 1842.[183] At that time, before the division of Queens County into Queens and Nassau Counties, the district attorney had his offices in Hempstead, a populous village located along the route of the Long Island Rail Road.[184] From this central location, he could devote his time and effort to ensuring that peace and prosperity were maintained. To his colleagues, Hadden was known for his "analytic and discriminating qualities of mind [that] commended him as a counsellor, while his kind disposition and personal amenity peculiarly endeared him to his friends and associates."[185]

Like Hoffman, Hadden was an enthusiastic member of and supporter of the Whig Party, and during the 1840s and 1850s served on the committee of the Whig Party of Queens County.[186] He was popular as district attorney for Queens, which led to his nomination for state senator in 1851 as a supporter of the improvement and enlargement of the Erie Canal system.[187] In May of that year, a special election was held in which Hadden lost to the former holder of the seat, William Horace Brown.[188]

As with so many officials who served in rural counties, many of Hadden's duties were taken up with a variety of cases, both small and large. He found himself prosecuting individuals for, among other things, the closing of public roads without permission, larceny and burglary and selling liquor without a license.[189] Following his terms as district attorney, Hadden worked in Brooklyn in his chosen profession, often defending his clients from the charges made by those he had once worked with. In 1852, he was one of the attorneys for Samuel Drury, who "was widely known from the various criminal trials in which he has figured."[190] Though Drury was accused of

perjury in a case of grand larceny in March of that year, it appears the trial ended in a hung jury.[191]

The eminence and experience of the attorneys that were representing the state was never in question. However, the attorneys that came to represent the accused in the case were, in no uncertain terms, a mixed bag to be sure—one young and relatively unknown and the other old and somewhat forgotten. The lead attorney for Nicholas Behan was Spicer D. Dayton (1819–72). Dayton was an attorney whose office was located in Riverhead, not far from the county courthouse where Behan's trial would take place. He was young, just thirty-five years old, and had been admitted to the bar on Long Island just a few years earlier. Spicer Dayton was apparently native to Long Island, though exactly who his parents were is not clear. In the early part of the 1840s, he traveled to Meadville, Pennsylvania, to attend Allegheny College but departed in 1844 before he could graduate.[192] He came back to Long Island, where he must have continued his studies, and was admitted to the bar on November 8, 1849, for the Second Judicial District of the City of Brooklyn.[193] He traveled out to Riverhead, the seat of Suffolk County, where he set up a small country practice. Dayton lived as a boarder in the home of the local constable, John Williamson, and his family. He met a local girl, Mary A. Conklin (1826–59), and in 1851 they were married.

As an attorney, Dayton was not very successful monetarily, though he did do a good deal of work at the Suffolk County Circuit Court and Court of Oyer and Terminer.[194] His name was associated with many small cases, such as those related to trespassing issues, repayment of debts, the stealing of grain and the like. From the beginning of his career up and until his representation of Behan, he faced off against many different small firms as well as the district attorney, William Wickham. He also worked with many notable attorneys, including the aforementioned Wickham before and after he was elected to office and the Honorable Abraham Topping Rose, one of the leading jurists in Suffolk County.[195] However, his career never took off. When he was admitted to the bar in 1849, it was alongside thirteen other men, nearly all of whom ended up being more successful than him.

Unlike Dayton, nearly all of the fellow admittees were mentioned in prominent publications of the day and achieved some status in the legal field. Among them were Andrew Edward Suffern (b. 1827), who served as district attorney for Rockland County; Thomas J. Lyon (b. 1816), who became counsel for the New York and Erie Railway Company and a member of the New York State Assembly; and William H. Pemberton (b. 1824), who became the district attorney for Westchester County.[196]

Dayton's biggest case appears to have been one he handled in conjunction with William Wickham and Abraham Rose known as *Robinson v. Robinson*, which was decided in the spring of 1853.[197] The case was comprised of two brothers who were fighting over shares of land given to them by another brother. The elder tried to mortgage the property, while the younger, who was underage, fought to protect his rights in the land. The trio of Dayton, Wickham & Rose, who represented the elder brother, lost to the firm of Miller & Tuthill.[198] Although it was a loss, it does show that the other attorneys must have had some respect for Dayton's talents in the courtroom.

So why would Nicholas Behan end up hiring a local attorney who was not as well known as others? It is possible that few local attorneys would even go near the case, considering the brutal and vicious nature of the attacks. Dayton may have seen the case as a way to improve his standing as an attorney. If he won, he would be celebrated for his legal acumen. He had little, if anything, to lose by taking the case. But he was not alone. Sitting by his side was another Long Island attorney by the name of Craig. There is little doubt that the attorney in question is none other than Samuel D. Craig (1777–1856), a once prominent New York City attorney who had left the metropolitan life for a quieter one on Long Island. Born in New York not long after the beginning of the American Revolution, Craig had established a successful law practice in the city by the early nineteenth century.[199] In May 1808, he was married to Miss Helen Kortright Brasher by the Reverend J.N. Abeel.[200]

As an attorney, Craig saw success and was soon a prominent legal advisor, maintaining offices on Vesey Street and later on Chamber Street in lower Manhattan.[201] In 1816, he was serving as an assistant justice in the mayor's court of New York, where he heard the case of *Cumming v. Arrowsmith*. Edward Arrowsmith, along with George Reeks, was accused of slandering the Reverend Alexander Cumming, minister of the Evangelical Independent Church on Rose Street. The tale behind this suit is as follows:

> *Mrs. Sarah Reeks sought out her pastor without her husband's knowledge because she and her husband were in desperate financial trouble. The pastor reported that he lent the couple money, ordered a sofa from the husband's workshop, paid a substantial deposit, and never received the goods. The minister claimed his kindness was repaid with charges that he had forged the order, and he defended himself in a slander suit.[202]*

Craig ruled in favor of the reverend, and the case was a big enough sensation in New York City that it spawned a short treatise on the trial that was published in 1819.[203]

By 1839, Craig decided to expand his business by continuing some legal work in the city while picking up other work on Long Island. He accomplished this through the placement of advertisements in local papers that noted that he would "continue his practice as such in the counties of Suffolk, Queens, Kings, and New York."[204] Craig had a summer home in the small village of Quogue, located along the south shore in Southampton Town, from where he could conduct his expanded legal business.

Another event that gave Samuel D. Craig's name some notice during this period was his involvement with the famous American poet and author Edgar Allan Poe (1809–49). A single letter survives amongst the papers of Poe, who was in 1844 involved with the *New York Mirror*, a city newspaper that "recently [had been] recast as a daily and weekly paper."[205] The letter, which was written to Craig from New York on October 24, 1844, is evidently in response to a threat (perhaps a lawsuit?) from Craig, possibly regarding something deemed libelous, that was published in the *Mirror*:

> *Sir, proceed. There are few things which could afford me more pleasure than an opportunity of holding you up to that public admiration which you have so long courted; and this I think I can do to good purpose—with the aid of some of the poor labourers and other warm friends of yours about Yorkville. The tissue of written lies which you have addressed to myself individually, I deem it as well to retain. It is a specimen of attorney grammar too rich to be lost. As for the letter designed for Mr. Willis (who, beyond doubt, will feel honoured by your correspondence), I take the liberty of re-inclosing it. The fact is, I am neither your footman nor the penny-post. With all due respect, nevertheless, I am Yr Ob, St Edgar A Poe.*[206]

Samuel Craig was quite aware of Spicer Dayton's abilities, as he had faced him several times since the young man from Riverhead had been admitted to the bar in 1849. Just two years prior to the Behan case, in the case of *Englehart v. Howell*, Dayton worked with both plaintiff and defendant to bring about a settlement of the case despite Craig's dissent to such an action.[207]

Would this partnership be the solution to Behan's problems? Perhaps not, but now the stage was set for one of the most publicized trials ever to be held on eastern Long Island.

Chapter 7
THE PRESS

B y the time of the Wickham murders, the American press had helped to transform the ways in which news was transmitted across the country. Major papers had appeared in American cities during the colonial era, most notably the *New England Current* and the *Pennsylvania Gazette*, published respectively by James and Benjamin Franklin. The papers of the late colonial and early republic era were highly partisan and often aligned with either the interests of a political party or those of its owners. They did not publish articles based on providing balanced content, which is the hallmark of most of today's newspapers, and were increasingly interested in making a good profit from the news. Though this was the case, reformers tried to alter how the news was reported. The author Hazel Dicken-Garcia noted the move by some elements of American society to try to reform the press in America:

> *In the early nineteenth century, critics believed the press was destroying social structure—eroding law and order and the institutions of the family, religion, and education. To counter these effects, they advocated, among other things, eradicating Sunday newspapers and "subversive" content such as news of crime, sex, and sporting events. In the process, they articulated the rudiments of journalistic theory and proposed what issues should be addressed by journalists, what functions should be undertaken, and what standards should be imposed.*[208]

This attempt failed, and the partisan and political nature of American newspapers and their owners would continue during the nineteenth

century, during which thousands of papers were in circulation across the United States. Gerald J. Baldasty remarked upon these transformations in his book *The Commercialization of News in the Nineteenth Century*: "Increasingly in the nineteenth century, news became a commodity valued more for its profitability than for its role in informing or persuading the public on political issues."[209]

The public was deeply interested in tales of torrid love affairs, murders and other ghastly or gruesome tales. This type of story would have been unheard of in an earlier period, but the sensational case of Mary Jewett, whose accused murderer was successfully defended by future New York attorney general Ogden Hoffman, changed all that. A prostitute who was brutally murdered in New York City in 1836, her case and its details forever changed newspaper reporting. University of California historian Patricia Cline Cohen noted, "Historians of journalism have long heralded the Jewett murder as the event that inaugurated a sex-and-death sensationalism in news reporting, a style of journalism that is utterly familiar to us now in the late 20th century."[210] Mary Jewett's own game of using aliases, lying about her past and inventing much of her own life helped feed interest in her tale.

The Jewett case may have been the catalyst, but it was James Gordon Bennett's *New York Herald* newspaper that made it into a gripping, sensational story for the public to consume. Founded in 1835, the *New York Herald* was "considered to be the most invasive and sensationalist of the leading New York papers…and [its] ability to entertain the public with timely daily news made it the leading circulation paper of its time."[211] Bennett said that the purpose of a newspaper was not "to instruct but to startle," and the *Herald* would attempt to do just that again and again.[212]

Long Island newspapers were not much different that those in New York City. Like their city counterparts city, local and regional papers such as the *Long Islander* (Huntington), the *Sag Harbor Corrector* and the *Brooklyn Daily Eagle* all made money by selling advertisements, which inevitably had an influence on what would and would not be reported. But unlike many of the papers published in New York City, such as the *New York Herald*, *New York Daily Times* and the *New York Tribune*, they did not have an extensive network of reporters and only rarely went out to seek stories or to investigate others.

The smaller papers, like the *Long Islander* and the *Corrector*, relied on picking up news from the larger papers and reporting it either word for word or in slightly modified format. The spread of the news was also greatly aided by the invention of the telegraph, which was patented in the United States in 1837. Over the next twenty years, its use spread quickly across the country,

culminating in the connection of America's eastern and western coasts in 1861. Papers far and wide could more easily report on distant news. Such was the case when Syracuse's *Evening Chronicle* noted that they had received information on the Behan trial "as the telegraph has before stated."[213] When the Wickham murders occurred during the summer of 1854, the American appetite was already whet for a gruesome and juicy story like the one unfolding on eastern Long Island. The fact that one of the victims was the brother of a prominent sitting district attorney only excited things further.

It's clear that when news of the murders got out, the New York City papers initially reported the news from the city using residents, friends or neighbors that had been in Cutchogue as the events first unfolded. The papers actually referenced and thanked these individuals in their publications. The *Herald* printed the following just two days after the murders occurred: "We are indebted for the above information to Mr. John Martin, of River Head, who came to the city last evening to notify the friends and relatives of the deceased."[214] The *Tribune* reported the same reference, taking the story nearly verbatim form the *Herald*, which had apparently been first to break the story.[215] A few days later, the *Tribune* scooped the *Herald* by securing further information on the murders through another North Fork native, placing a similar thank you in their publication: "Sincere thanks to Mr. Oliver B. Goldsmith, the eminent Writing Master of No. 362 Broadway, New-York, for his signal aid to him in collecting the above facts, and also for the generous hospitality which he extended."[216]

Even those closely involved with the case provided information to the newspapers. Dr. Benjamin Carpenter, who had witnessed so much of the horror, submitted information to the press regarding the murders. In his testimony at Behan's trial, he stated that he "wrote an account for one of the papers in the city" and "acknowledged that the letter that appeared [in the *New York Tribune*] signed with the name Zimmermann was made up from one which he wrote."[217] Sheriff Samuel Phillips, who would later be intimately involved with the prosecution of the accused, had the unimaginable audacity to publish a confession purportedly made by Behan while he was transporting him to Riverhead in his own newspaper, the *Republican Watchman*. Taking such an action was as hard to believe then as it would be today, though in his defense, Phillips claimed that his article supposedly included the "very words of the prisoner."[218]

Of course, while the source of the information is thanked, the reporters who wrote the story are not mentioned. In today's world of bylines and detailed references, it is hard to imagine not receiving credit for one's work. However,

crediting journalists was fairly uncommon until the very late nineteenth and early twentieth centuries, when several reporters began achieving national recognition for their skills. None of the stories that appeared in the press regarding the murders referenced anything other than the paper from which they took the story. And it must be remembered that these reporters were taking notes—not on a computer, iPad or other electronic device—but on paper with a pencil, making it all the more difficult to capture everything going on around them.

As soon as the gravity of the situation was realized, New York City–based papers immediately dispatched reporters to the North Fork. They arrived by train from the city, a three-hour ride at the best of times. Not far behind were two metropolitan police officers by the name of Dowling and Lord. The two had been ordered along with others to Cutchogue by New York City judge Justice Osborne, who had been raised in that part of Long Island, to "make a thorough search for the assassin and to render all the aid in their power to the local authorities in bringing him to justice."[219]

A *Tribune* article published on June 7 noted that it came "from our special reporter," who must have already been on site.[220] He and others must have arrived on the North Fork by Sunday, June 4, when the intensity of the search and sighting of Behan was in full swing. The *Herald* noted that they too had a special reporter onsite by Sunday for "the purpose of ascertaining more fully the facts and circumstances in this horrible affair" and who visited the scene and evidently interviewed those present in the community.[221] While the *Herald* initially kept up with the *Tribune*, they seemed to tire of the subject more quickly, while the *Tribune* continued to report on the story through Wednesday. In fact, the article published by the *Tribune*'s correspondent was full of details and information that could be obtained only through detailed investigation and a firsthand account. Their reporter was able to secure access to the Wickham homestead, certainly a coup for the paper, and offered the following description of the scene to its readers:

> *The corners of the walls of the rooms and passages through which the murdered must have groped his way show marks of his bloody fingers and smutches of blood. The garret where the negro boy lay is covered with bloody signs, while the pallet upon which he slept was covered with clotted blood. The negro boy now lies in the room in which the double murder was committed. He is quite conscious of all that occurred up to the time of the reception of his injuries. He is not aware of the fate of his master and mistress, whom he believes still living. The best of care and attendance is*

bestowed upon him, and he will in all probability recover, although his head exhibits some fearful marks of the axe.[222]

The *New York Daily Times* offered up several articles on the murders and, like its competitors, sent a special reporter to the scene to ensure that they would offer "very full and authentic details of the murder."[223] It featured an article that Wednesday on the front page that filled nearly four columns. The *Times* also published information provided by a "correspondent at Riverhead" who apparently was not affiliated with any major paper but provided additional details on Behan's capture and confession.[224]

The *Brooklyn Daily Eagle*, perhaps the Long Island's most recognized and widely read paper of the period, covered the murders in great detail, though they wrongly reported that Stephen, the young African-American boy, had died.[225] Eventually, the *Eagle* was, in a nod to its extensive connections on the island, able to secure its correspondent a personal interview with the prisoner.[226] Even the *Long Island Farmer and Advertiser*, located in Jamaica, Queens, was able to field its own correspondent to cover the events as they unfolded.[227]

THE CUTCHOGUE MURDER.—On our third page may be found the details of a horrid butchery, which took place in one of the most quiet villages of the East end of Long Island. A wretch, without provocation, entered the house of his late employer at Cutchogue, L. I., and with a post-axe murdered a gentleman, his wife and servant. The victims, JAMES WICKHAM, Esq., and FRANCES POST WICKHAM, were well known in this City and throughout the Island. The outrage occurred at the birth-place of Judge OSBORNE, of this City, through whose offices a posse of New-York policemen have been selected to scour the woods and assist in bringing the murderer to justice.

Detail of the headlines that appeared in the *New York Daily Times,* June 1854.

New-York Daily Times.

THE WICKHAM MURDER.

CONFESSION OF NICHOLAS BEHEEHAN.

THE CORONER'S INVESTIGATION.

TESTIMONY BEFORE THE JURY.

FUNERAL OF THE VICTIMS.

IMMENSE ATTENDANCE OF CITIZENS.

FURTHER DETAILS OF THE MURDER.

Detail of the headlines that appeared in the *New York Daily Times*, June 1854.

Local papers such as the *Long Islander* and the *Corrector* took their cues from the city papers, often reproducing their articles within their pages.[228] While no less detailed in their reporting, the east-end papers tended to be less sensational than their New York City siblings, except when reproducing text in full from other publications. Unlike the papers published in the city, the newspapers on Long Island tended to be weeklies, not dailies, with no special morning or evening editions. News did not pour out through them, rather it trickled, and this certainly had an effect on how quickly news traveled through the insular communities.

The news of the murders was carried not only by the newspapers mentioned above but also in numerous other papers that had access to the telegraph. Papers across New York State carried the story, and stories were included in publications such as the *Oneida Sachem*, the *Rome Daily Sentinel*, the *Corning Journal*, the *Batavia Spirit of the Times*, the *Niagara Falls Gazette*, the

New York Christian Intelligencer, the *Madison Observer*, the *Buffalo Daily Courier*, the *Binghamton Broome Republican*, the *Syracuse Daily Standard*, the *Daily Journal*, the *Wesleyan*, the *Evening Chronicle*, the *Albany Evening Journal*, the *Utica Morning Herald*, the *Daily Gazette*, the *Oneida Weekly Herald*, the *Lewis County Republican* and the *Oswego Daily Journal*. The reporting was not reserved only for New York papers. Those located in nearby Massachusetts (*Lowell Daily Journal & Courier*) and Pennsylvania (*Democrat and Sentinel*) also carried the story, as did papers as far away as Ohio, where the *Gallipolis Journal* reported on the tragedy.[229] Nearly all of the articles that appeared in these publications tended to be repetitions of articles or material that had already appeared in other newspapers.

With papers across the Northeast delving deeper into the murders, it was no surprise that the general public wanted to know even more. People wanted something extra—something more than just print on a page. And so they began to travel out onto Long Island in search of a glimpse of the man accused of murder.

TOURISM

Prior to the turn of the twentieth century, a common form of recreation for tourists was to pay an admission fee to the caretakers of public buildings or institutions. Anyone could tour places such as lighthouses, government buildings or military installations. For amusement, visitors could walk through establishments such as insane asylums, jails or other places where unfortunates were confined and look at the inmates in their cells. County Hall in Riverhead held the jail for the eastern half of Suffolk County and had probably been visited by many people looking to pass the time viewing those incarcerated for crime or unpaid debt.

Prior to 1727, the honor of becoming the county seat was being sought by both the Town of Southold on the North Fork and the Town of Southampton on the South Fork. To be fair to each community, court hearings and other administrative measures were alternated between the two towns.[230]

In 1727, the justices of the peace in Suffolk County, seeking a solution to the situation, requested an act from the Colonial Assembly to erect a courthouse and "gaol" (jail) at a location convenient to both Southampton and Southold. Land located at the border between the two at the head of Peconic Bay was chosen for the building. In 1792, the western end of Southold was formed into a new independent township known as Riverhead, which encompassed the nearly sixty-year-old courthouse and gaol.[231] The area was often referred to as either Riverhead or Suffolk Courthouse.[232] The courthouse was a simple framed wooden structure, and when constructed, it was barely large enough to accommodate the functions that the county planned.[233]

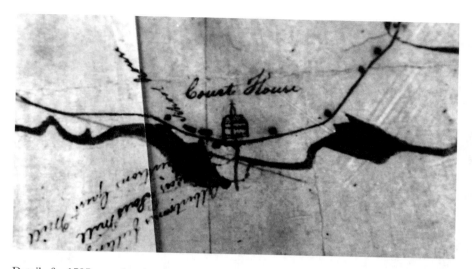

Detail of a 1797 map showing the original Suffolk County Courthouse of Riverhead. *Courtesy of Suffolk County Historical Society.*

County Hall also served as the central meeting place for the county supervisors. It housed not only the court but also the jury room and the jail. In 1784, most of the structure had to be rebuilt due to damage done during the Revolutionary War.[234] Up until 1790, Riverhead was barely a hamlet. It had only four or five houses and a gristmill.[235] In 1804, a traveler passing through Riverhead described the courthouse as a "poor decayed building" and the village as "a miserable hamlet containing about ten or twelve houses near the efflux of this river."[236]

The courthouse was renovated, remodeled and enlarged in 1819 and 1825. By 1854, the building was considered virtually unusable for its original purpose. In poor shape, some felt that the building should be condemned. The land on which it stood had been reduced to a mere ninety-two- by ninety-seven-foot lot, as properties around it had been purchased and built upon.[237] In 1854, the county purchased farmland from the Griffing family and laid out Griffing Avenue so they could build a larger courthouse and jail along the new road.[238]

On June 7, Nicholas Behan was transported to the county jail in Riverhead. Samuel Phillips, sheriff of Suffolk County, personally escorted Behan up to the jail. During the ride from Peconic to Riverhead, the sheriff, who was better known as a founder and editor of the *Republican Watchman* newspaper of Greenport, chatted with Behan.[239] Probably an easy man to talk to, Phillips later testified that Behan had confessed to him and to Dr.

The Perkins store was originally built circa 1727 as the new courthouse for Suffolk County. The location, which straddled the border between Southold and Southampton Towns, was chosen to placate each of these townships, which thought that the courthouse should be located in their jurisdictions. *Courtesy of Suffolk County Historical Society.*

Carpenter to the murder as he was being tended to for an attempted suicide. He said that Behan described the entire murder in great detail. It was to the old, decaying eighteenth-century courthouse that Nicholas Behan was brought to await prosecution for murder. When he arrived, he was given the structure's strongest cell in the lower level of the building. As the jail's star attraction, his captors wanted to make sure he remained incarcerated.

The jailers and caretakers of institutions where the public was allowed to visit were normally permitted to pocket the admission fees as a perk of the job. In Riverhead, the general public was eager to view the accused perpetrator of the Wickham murders. Suffolk County jailer Daniel R. Edwards was well compensated for the trouble of having tourists around. Hundreds of tourists passing through Riverhead on their way to hotels and boardinghouses on both the north and south forks of the island stopped in at the jail asking to see "Nick." The crowds swelled to the point that after two weeks, they could not handle all of the people. The profitable sideline income for the jailer had to be sharply curtailed.[240]

Newspapers kept the story alive by running periodic updates on Behan's confinement. When Behan was first confined, he was "very unruly in prison— so much so that he has to be tied down to the floor."[241] Rumors flew that Behan's fellow Irishmen were banding together to try and mount a rescue from the jail. The sheriff, believing the rumors, tightened security around the building.[242] In the beginning of September, it was noted that Behan seemed comfortable in his confinement, and reporters complained, "He acts in the same pompous manner as he did when the key was turned upon him, and yet attempts to deny and repudiate the confession he made. This braggadocio air, however, will avail but little…when the trial takes place."[243]

Authorities were concerned that Behan would make another attempt at suicide. His prison cell was cleared of everything except a bed. His meals were delivered on a tin plate and cup through a sliding door in his prison cell. Behan was not allowed to have any type of flatware or crockery. The jailer also banned Behan from having any visitors in his cell to prevent him from having "incendiary ideas, nor have any opportunity to destroy himself."[244] Behan was sure that Peter Connor in Greenport would be able to give him an alibi that would set him free. He informed the reporters that when he got out of jail, he was going to marry Ellen Holland.[245]

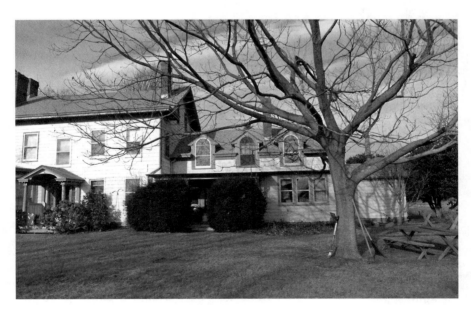

The south side of the Wickham farmhouse. The tree shown on the right replaced the ancient tree under which James and Frances Wickham's funeral was held in 1854. *Authors' image.*

The grave of Frances and James Wickham. The marble obelisk is surrounded by smaller fence posts that originally held chains to prevent tourists from trampling the grave. *Authors' image.*

On Monday afternoon, June 5, just several days after the tragedy, the Wickhams were laid to rest together. The funeral, which was officiated by Reverend Mr. Ezra Youngs and Reverend Mr. Joseph Sinclair, was held in Cutchogue. Mourners and undoubtedly a number of tourists from up to forty miles away attended the service, as well as every citizen of Cutchogue. The Long Island Rail Road ran a special train to transport friends and family to Cutchogue so that they could be present at the funeral. Frances Wickham's two sisters and their husbands, Elizabeth and Abram Skidmore and Mary and Charles H. Rogers, as well as one of her brothers came on the train. Some of James Wickham's maternal family members also used the special train.[246]

Frances and James Wickham were laid out in caskets with silver coffin plates attached to the lids that gave their names, the date of death and their ages. The ceremony was held in the backyard of the Wickham home under a willow tree. The bodies were carried out of the house and laid on a white bier.[247] After the service, church bells tolled as the bodies were transported in a funeral procession from Cutchogue to the Mattituck Presbyterian graveyard.[248] Newspaper accounts note that the procession had over two hundred vehicles and stretched over two miles.[249] Buried together, Frances and James Wickham were laid to rest in the family plot. The grave was marked with a large white marble obelisk and surrounded with a chain fence to keep the ever-growing throngs of tourists from trampling the grave.

THE TRIAL

During the nineteenth century, criminal cases in Suffolk County were tried in a two-court system. The case was first reviewed by the court of sessions, and if it was determined that a crime had been committed, the case was then sent to the Court of Oyer and Terminer for trial and determination of punishment.

In 1854, the Suffolk County Court of Sessions was presided over by county judge William P. Buffett alongside Henry Huntting and Enoch F. Carpenter, who served as the justices of sessions.[250] They oversaw a grand jury consisting of approximately twenty-three jurors. On October 3, the jury was to decide if the accused had committed the crime they were charged with in the twenty-three cases they had to review. Among the cases on the docket in the fall session of court were the two charges of murder against Nicholas Behan.[251] After reviewing the details of each situation, if the majority of the grand jury found that the perpetrator had committed the crime, they would then issue a bill of indictment and have the case moved on to the next step. Due to the overwhelming evidence of wrongful death in the inquest jury's report, a bill of indictment against Behan was quickly passed.[252] His trial date in the Court of Oyer and Terminer was set for October 25, 1854.

The Court of Oyer and Terminer handled all criminal trials passed to it by the Court of Session's grand jury.[253] The court consisted of a rotating group of judges who could be pulled from the Supreme Court and circuit courts. In addition, a minimum of two judges from the county courts also

Henry Huntting (1818–1896) of Southold, painted by Thomas Currie-Bell. A justice of session, Huntting was one of the judges who tried Behan for the murder of the Wickhams. *Courtesy of Southold Historical Society.*

Selah Brewster Strong (1792–1872), justice of the Supreme Court of New York who presided over the trial of Nicholas Behan. *Courtesy of Long Island Museum of Art, History and Carriages.*

sat on the bench, and a twelve-man petit jury would be formed to ultimately determine the outcome of the case.[254] In Riverhead, the Court of Oyer and Terminer met on a semi-annual basis in the spring and fall, usually immediately after the court of sessions concluded. The docket for the 1854 session was anticipated to be quite busy. In addition to the Wickham murder case, there were three other people in jail with Behan awaiting trial. Two were accused of grand larceny and one of attempted rape.[255]

It was possible that the notoriety of the Wickham case made the wheels of justice spin a bit faster than usual. Behan's trial was moved up, and the formalities began on the clear and pleasant afternoon of October 24 in the courthouse where he had been lodged since early June.[256] The case was set to be tried in a court presided over by four judges and a

jury. Three of the judges were the same ones he had faced at the Court of Sessions. The fourth judge was William Wickham's mentor, Selah Brewster Strong from Setauket, now a Supreme Court judge. Nicholas Behan was unshackled from his cell and brought into the courtroom. He walked to the prisoner's box between two officers. Appearing confident in a new black suit, Behan appeared unconcerned about his fate.[257]

Alexander Hadden, the lead prosecuting attorney, then began reading aloud the bill of indictment to the court. He described the known details of the murder of James Wickham. Judge Strong asked the accused if he wanted to be tried on the charge of murder. Behan replied, "Why yes, I do—if the folks I want to come are here." Samuel D. Craig, the lawyer who represented Behan along with Spicer Dayton, told him to be quiet and then replied for him: "Not guilty."[258] Hadden then continued by reading the bill of indictment for the murder of Frances Wickham. Again Judge Strong asked if Behan wanted to be tried on the charge of murder. Behan retorted, "Who says all that?" Strong, apparently wondering why Behan was speaking for himself, asked Behan if he had a lawyer and if not did he want the court to assign one. Craig interrupted the exchange to state that he was the lawyer for the defense. At that point, the judge asked Attorney General Ogden Hoffman, who was overseeing Behan's trial, which case he intended to prosecute first. Hoffman replied, "The murder of James Wickham."[259]

Judge Strong notified the almost sixty potential jurors that they would be sitting in judgment on not only the Wickham murder case but also the trial of John Hempstead, who was accused of grand larceny for stealing fifty dollars from the store of Charles Wiggins in Greenport.[260] All of the men were eager to be part of the jury. Samuel Craig interviewed each candidate, asking if they had yet decided the guilt in the case. One man was turned away from the jury selection on the basis of non-residency. After interviewing all of the potential jurors, the lawyers finally agreed on twelve men, all of whom were married. Five were farmers, two were carpenters, one was a farm laborer and four were either retired or unemployed.[261] With all the administrative details of the case settled, the court adjourned until the following day.

On Wednesday, October 25, the weather continued to be pleasant as the court doors opened at 8:00 a.m., and the spectator area was instantly swamped with an avid audience. Alexander Hadden opened the first day of the trial with a summary of the murder. Then the first of the witnesses, William Wines of Greenport, was called to the stand to testify. William Wines was the Southold town coroner and the man who had held the inquest on the bodies and crime scene in Cutchogue. When asked about the last time

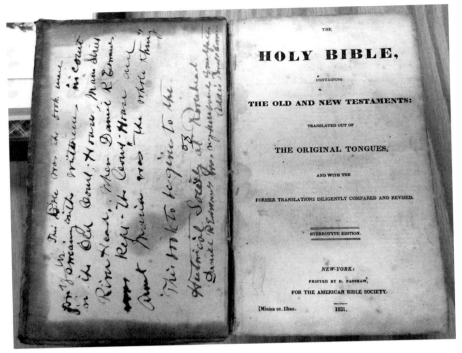

Bible used to swear in witnesses during the trial of Nicholas Behan in the Suffolk County Courthouse. *Courtesy of Suffolk County Historical Society.*

he had seen James Wickham, Wines responded that it was on June 3, when James was lying unconscious from the attack. "It was truly deplorable," he said. "He lived until evening; the wounds on his head were very bad."[262] He had been summoned to the scene of the crime by Dr. Carpenter. Wines's first step was to take each person involved in the events of that night up to the scene of the crime to view the blood-splattered room and the remains of Frances and James Wickham before interviewing them. After interrogating each of the participants in the horror of that night, he and his jury had reached the inescapable conclusion that Nicholas Behan was the lone attacker and murderer.

Next into the witness box was Ellen Holland. Holland told the court that the last time she had seen Nicholas Behan was on the Tuesday before James Wickham's death and that she hadn't seen him since. When questioned, Holland admitted that Behan had proposed to her on several occasions but that she had refused him each time, including the last, which was three weeks before the tragedy.[263]

Ellen Holland was then asked to state what happened on the night of June 2. She attested that she and Catherine Dowd had gone to bed in their attic room at nine o'clock. "Mr. Wickham was in his bedroom," she said. "Then I saw Mrs. W in the hall when I was on my way to bed. On the hall of the second floor, she bid me good night."[264] She was later awakened by screams and groans coming from the bedroom of the Wickhams, which was located almost directly below her room.

The lawyers interrupted her testimony to display to the jury a floor plan of the house so that they could trace the movements of the evening. Holland then continued to state that the screams and groans were accompanied by the fierce barking of the family dog. She was quite startled at all the noise and woke up Catherine Dowd before going to open the door. She saw a light reflecting up the stairs from the hall below. She thought she heard a man climbing the stairs to the attic and urged Dowd to hide with her in the darkest part of the attic. After a short while, she heard the Wickhams cry out, "Oh! Nicholas!" Upon hearing all of the noise, she then urged Catherine Dowd out of the window and instructed her to run to William Betts's for help. She then turned to go downstairs to help the Wickhams but changed her mind. She wondered if she could get out by going down the stairs to either the front door or the kitchen door, but she wasn't sure if she would come across any "resistance" to her taking that route. She eventually decided that climbing out the window was the safest way out of the building.[265] Holland followed Catherine Dowd's route out the window and escaped from the house. Not knowing which

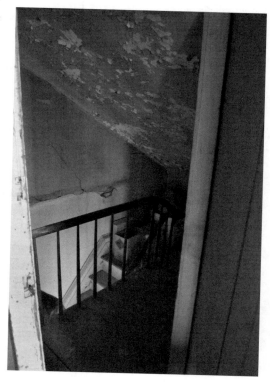

The switchback staircase leading to the attic of the Wickham house, where Ellen Holland and Catherine Dowd's room was located. *Authors' image.*

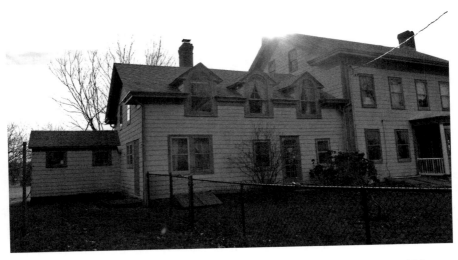

Exterior of the north side of the Wickham house showing the kitchen wing roof, which Holland and Dowd climbed onto before accessing the milk house roof to reach the ground (the milk house was located approximately where the small wing is to the left). *Authors' image.*

way Dowd had actually run for help, Holland hurried down the main drive toward Joseph Corwin's house.

Subsequently waking the Corwins, Holland later returned to the house in the company of others. The next morning, she found "a straw hat on the furnace in the sink room. I had not seen that hat there from the time that Nicholas left till that morning. I had used the sink room the day before. There had been men passing in and out of the sink room that morning."[266] After Nicholas Behan was captured in Peconic, he requested that the sheriff allow him to stop and see Ellen Holland as they passed through Cutchogue. Phillips granted his request, and the group drove up to the Wickhams' farmhouse. Holland ran up to the stopped carriage and asked him if he had murdered the Wickhams. "Yes," he replied, "and you were the cause of it." She burst into tears and ran back into the house. Behan then turned to Phillips and demanded to see the Wickhams' bodies, but the sheriff denied the request, and the carriage returned on its journey to Riverhead.[267]

Holland was then questioned by Behan's lawyers about her relationship with him. She confessed her ignorance and that she could not remember how long she had known Behan before she became "intimate" with him.[268] She again admitted that he had proposed several times but that she had always turned him down. He had also given her a number of presents, including a ring, a book, a breastpin and a pair of shoes.[269] When questioned about

Behan's personality, she stated that when he was angry, he was "rough" in his language and manner and would swear a great deal.

Lastly, the lawyers wanted to know about Behan's last meeting with the Wickhams. After he had been dismissed, Holland had witnessed from a distance his return to the farm. She replied that when she last saw him talking to Mr. and Mrs. Wickham next to the hog pen, they seemed to be having a friendly enough conversation.[270] Holland was then excused from the stand.

Samuel Tuthill was called to the stand next. Although he lived in Cutchogue, Mr. Tuthill said that he did not know Nicholas Behan personally, only by sight.[271] He had seen Behan once in the shoe shop in Cutchogue.[272] Tuthill, who lived on the street that led up to the train station, recalled, "I saw him on Friday, the day previous to the murder. It was when the accommodation train was passing Cutchogue between two and three o'clock in the afternoon. He passed from the depot house to the platform and got into the cars. He had a trunk, and there was a straw hat on his head."[273] When asked about his acquaintance with James Wickham, Tuthill stated that he did not visit the Wickhams' farm because he was afraid of the couple's large dog, which had attacked him once when he got too close to the property.[274]

Steam locomotive on the main line from Southold to Greenport. It was on this same line that Behan traveled to and from the murders. *Courtesy of Southold Historical Society.*

As Tuthill left the stand, Andrew Byrnes, a brickyard owner, was called to testify. He said that he had seen Nicholas Behan twice that week—once on Wednesday before the murders and then again on Friday night at his house in Arshamomaque, which is two or three miles west of Greenport. When questioned about what Behan was wearing, Byrnes replied, "As far as I can recollect, [he was] wearing black pants, black waistcoat and straw or chipped hat."[275] Byrnes said that Behan asked for directions to Greenport before leaving his house about 8:30 that evening. However, Byrnes did not see which way Behan headed after he left his house.[276]

Hadden then rose and began the cross examination of Mr. Byrnes, asking how long he had known the accused. Byrnes replied, "I knew Nicholas only a few days before the murder. I had engaged him to work in the brickyard at $18 a month and board."[277] Byrnes had invited Behan to stay overnight at his house because of the lateness of the hour, but Behan had refused, citing that friends were expecting him at Peter Connor's in Greenport.[278] Byrnes had agreed that Behan could wait to start the job until the following Monday, as Behan wanted some time off to spend with friends. Byrnes said he saw him again on Wednesday but did not finalize the arrangements for the job because he thought that Behan was drunk. When he saw him again on Thursday morning, Behan did not appear to be hungover and was drinking sarsaparilla while he settled the details of starting the job. Byrnes testified that he didn't see him again until the trial.[279]

John Thompson, a resident of Southold and the man who nearly captured Behan, then took the stand. He told of how Nicholas Behan had come to his house the evening after the murders. Thompson recounted how Behan resisted being taken in to authorities and then pulled out his pistol and threatened Thompson's life before fleeing to the east with several of Thompson's neighbors giving chase into a nearby swamp.[280]

After Thompson stepped down, William M. Betts, the Cutchogue hotel owner and storekeeper, stepped into the witness box. Betts began his testimony by stating that he lived about an eighth of a mile from the Wickhams and that he had known the accused for about two years. He stated that he thought Behan had left the farm on the Tuesday before the murders and that he had last seen Behan in the toolshed at the Wickham farm. The prosecuting attorney asked Betts what they discussed in the toolshed. Betts responded that Behan owed him twenty dollars and that he asked Behan to pay the debt.[281] He said that James Wickham gave Behan ten dollars toward the bill and that Wickham also persuaded Behan to give up one of his two pistols to pay off the rest of the bill. When Behan

left Wickham's farm, he left in Betts's care a trunk with Mrs. Wickham's name on it.

Betts said that the next time he saw the accused was on either Wednesday or Thursday before the murder. Behan had arrived at the store at nine o'clock in the morning and asked for the trunk because he had gotten a new job at a brickyard. While he was in the store, he spoke about Mrs. Wickham and Ellen Holland. Behan told Betts that he wanted to marry Holland and admitted that he had taken money out of her trunk but had taken no more money than what he felt she owed him.[282] In recounting the conversation, Betts also stated that Behan said to him:

> She [Ellen] had one hole in her body and he would make another. He appeared considerably excited about her, and he threatened something about Mrs. W for interfering between Ellen and him, in consequence of which she had refused him.[283] The same night, about sundown, Mr. and Mrs. W drove up to the door, and he [Behan] appeared excited and was going to the door. I thought he was going to speak to him, and I said he must not say anything in front of the door; I would not have it, and he went back.[284]

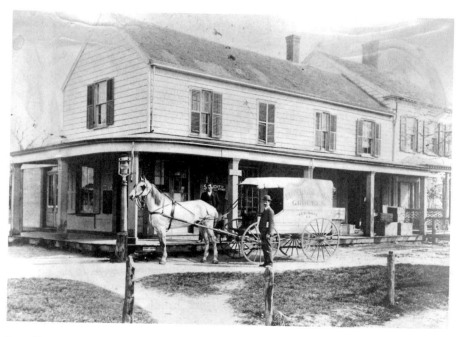

Betts Hotel, located on the corner of Main Road and New Suffolk Road in Cutchogue. Owned by William Betts, the building served as a hotel, general store and post office for the area. *Courtesy of Southold Historical Society.*

At this point, the court took a break for lunch. While judges and lawyers retired to their offices for their midday meal, spectators who had not brought their own lunches rushed from the courthouse in search of a place to eat. Other than the Long Island Hotel or the Suffolk Hotel, both of which were mere steps from County Hall, there was a bakery two blocks away or Timothy A. Corwin's saloon on the north end of the community next to the railroad station. Time was of the essence. The trial's audience had to order, consume their meals and return in time to reclaim their seats.

Dr. Benjamin Carpenter was the first witness on the stand after the court had reconvened. Carpenter started his testimony by describing when he was notified of the murders at midnight. The doctor was the first person in the house and found the bodies of the deceased in the southeast corner bedroom.[285] "Mr. Wyckham [sic] was lying upon the floor, attempting to rise. Mrs. Wyckham [sic] was lying upon a plank, apparently lifeless…[she] was in a state of semi-nudity."[286] The doctor testified that such a large portion of Mrs. Wickham's brain had fallen out that he was able to stick his finger in the head wound and was unable to find the bottom of the injury. He also noted that her clothes appeared to be "tucked up."[287] Carpenter sent someone to notify the members of the Wickham family and another person to notify the law in Greenport.[288] He ended his testimony by stating, "The deceased was, in fact, literally hacked to pieces."[289]

The bloody ax found under the Wickhams' bedroom window was pulled out and exhibited by the prosecuting attorneys. Carpenter continued that in addition to the serious wounds on his head, James Wickham also had several places on his hips, legs and arms where the outer skin was scraped off. There was blood covering the floors and walls of the room. It was Dr. Carpenter's opinion that James Wickham had half a dozen wounds that could have caused his death. He noted that while Wickham had lived for another twenty hours after he was found, he never regained consciousness, although he moaned with pain on occasion. Carpenter testified that he stayed with Wickham until the end and did not join in the nighttime search for the culprit.

Dr. Carpenter next saw Behan when he was captured and placed under arrest in the barn of Franklin Overton in Peconic. He said that when he arrived, Nicholas Behan was lying on his back with a wound that extended for about two and a half inches across his throat. It was his professional opinion that the laceration was probably a knife cut.[290] The patient appeared stupefied, refusing to open his eyes, but his pulse was not consistent with the state of lifelessness that he was exhibiting. After treating the wounds, Dr.

Carpenter said to Behan, "This is all nonsense. Nicholas, you are not hurt much; there is no use of feigning yet. You know me and what I have been doing for you, and you know what you yourself have been doing." Carpenter paused and then continued, "I should hardly have expected to be called to see you under such circumstances. Mr. and Mrs. Wickham are both dead—horribly murdered."[291]

The defense objected when the doctor started to quote Behan's reply to his statement. The judge overruled the objection, and Carpenter continued his testimony, stating that Behan affected surprise at the news of the Wickhams' death.[292] He then bargained with Carpenter that if he would tell everyone else in the barn to go away, he would tell him the truth about the situation. The doctor responded by asking the others to leave him with his patient. Behan then began to tell his version of the events of the night of June 2. After Behan finished his confession to the doctor, he was loaded onto a wagon to be transported to Riverhead along with the doctor and Sheriff Samuel Phillips. Behan repeated his confession to the sheriff during the journey. Carpenter then testified, "When I went to the Wickhams', I found the door he spoke at in his confession fastened with a rope to the rafter. The lamp and axe were found under the window, as he subsequently told me."[293] Just before he stepped down from the stand, the doctor paused and mentioned, "I am reminded by this of a question I asked him. I asked him how long he had contemplated this, and he said about a week before."[294]

When Carpenter was released from the stand, William Betts was asked to return to the witness box. Betts was then asked to go back over the details of his involvement in the case starting from when he and the other men surrounded the house and broke down the door. He mentioned that after discovering Mr. and Mrs. Wickham, he went to check on the welfare of Stephen Winston: "I did not find [him] till afterwards. Stephen was lying on the floor. I saw some blood and hair on the washstand."[295]

Betts was shown the ax and lamp and positively identified them as the items found under the Wickhams' bedroom window. He was then shown the hat that was found in the kitchen. Betts would not swear that it was the same hat he saw in the sink room, but he did think it was very similar. He was then questioned about when Behan was captured. Betts testified that he was present just after the capture and was at the barn where Nicholas Behan was being held:

> *There were a great many persons there around the barn. Some harsh threats were made against him. I saw Dr. Carpenter...there were some who*

proposed to hang him up immediately. I had a conversation with the prisoner
after the doctor. Behan recognized me and shook hands with me. He told
some things to me that he told to Dr. Carpenter. I know nothing unfavorable
of the prisoner before this…his general reputation in the neighborhood was
that he was pretty quarrelsome at times. I never knew him to take a glass
of spirituous liquor.[296]

Behan, who had been quiet up to this point, suddenly interrupted the proceedings. He had been mulling over the events being recounted in the courtroom and had decided that he had a question for William Betts. Disregarding the line of questioning that his lawyers were trying to pursue, he called for Mr. Craig to ask Betts if Mrs. Wickham had been in the wagon when Ellen was there or not. The entire court paused, struggling to understand Behan's question, which did not fit into any of the events that had been related at the trial. After a moment of silence, Betts responded that he did not know but did not think so.[297]

Joseph Corwin of Southold, who was among the men with John Jones when he stumbled on Behan lying on his back in the swamp, was then called to testify. While in the witness box, Corwin recounted that he had realized Behan was lying with his head partially covered in the water and that he jumped in and pulled him out. He said:

He was in a mudhole, his head lying partly in the water…bushes lying very
thick about him. It was boggy and swampy for a considerable distance all
around where he was found…the place where he was was very difficult to
access. I did not take him to be dead when I saw him; his face looked well
enough, but the blood was running quite freely from his neck.[298]

After being sworn in as the next witness, John S. Hallock, a local farmer from Cutchogue, stated that he was part of the search party that formed after Behan escaped from John Thompson's house. Hallock was part of the line of men at the railroad tracks looking for Behan. During the night, he saw someone attempting to break through the line from the eastern part of the swamp. Hallock thought the man was wearing a frock coat and was pretty sure that he was the man they were searching for. Hallock testified:

I hailed him and told him to stop. He paid no attention and kept advancing
toward me. I hailed him again and told him if he did not stop, I would
shoot. He then, I supposed, took a pistol from his pocket. He aimed at me

and snapped [the] *pistol at me. I heard a noise like the report of a cap. I fired at him when he turned and ran back.*[299]

After Hallock stepped down, Stephen Winston, the other farm laborer on the Wickham farm, was called to the stand. Winston, the first victim of the attacks and the only survivor, had mostly recovered from his injuries four months earlier. He stated to the court, "I went to bed about half past nine on Monday night. I know nothing that happened to me after I went to bed that night."[300] Winston did not regain full consciousness until two or three weeks after the attack. He knew something had happened when he awoke and felt the bandages on his head. Winston testified that he had worked for James Wickham for six years and had known Nicholas Behan for about three years. He also recognized the hat that was found on the premises: "Nicholas wore a straw hat that summer. I can't say that I would know the hat he wore; this looks like it. I was at the furnace the day before; there was no hat there."[301] He also positively identified the post ax as being one used on the Wickham farm.[302]

Winston was then questioned about the Wickhams' dog. He noted that the dog was usually very mild in temperament but that he thought it would either take hold of a stranger if they came into the house or keep strangers out of the house if no one was around. Stephen said that the dog was in the house the night of the murder and was free to roam the three rooms of the kitchen wing at night. When asked if the dog could have come to the Wickhams' aid, he replied, "He could not go upstairs because he never learned it; he could not go upstairs because he had a door to open."[303]

Then Stephen Winston was asked about his relationship with Nicholas Behan. He said, "I had a quarrel with Nicholas a long time before this. I did not mind him when he told me to do something. I had no malice toward him, and I don't know that he had any toward me. He made me a present of two French fiddles, one just before he went away. He also made me a present of candies and was very good natured toward me."[304] In contrast, Winston said that Ellen and Nicholas had a stormy relationship and tended to quarrel on occasion. He thought that they didn't really like each other when Nicholas first started working at the farm. Winston also said that he was present the day that Nicholas left the farm. Winston noted that he and Mr. Wickham were present when they searched Ellen's trunk for money and found twenty dollars. Winston continued:

Nicholas had been charged with taking ten dollars from the trunk. Ellen said, "There, there, he has taken it." Then she asked Mrs. Wickham if

Mr. Wickham wanted her in the kitchen. Ellen went into the kitchen; this was before the trunk was searched. Then they went up and searched the trunk. He [Nicholas] then asked her for the presents, and she refused to give them up. After this, he watched his opportunity and took the money. He courted her...but she did not like him.

Winston then paused for a moment. Spicer Dayton asked him if he had ever overheard Ellen Holland conspiring against Nicholas Behan with a man named Michael Marsh. Winston replied:

I know Michael Marsh. He used to come to Mr. Wickham's about three or four times a month. Nicholas said to Mr. W that Ellen and Marsh were the cause of his being turned away. Marsh slept there [at the Wickhams'] at night with Nicholas. When he was there at night, I did not see him [Marsh] court her. She seemed pleased with him. There were no disturbances with Nicholas before he came.[305]

Barnabas Wines, the constable of Southold, took the witness box after Winston stepped down. Wines had searched and collected the belongings of Nicholas Behan in Greenport after his arrest. He found a coat, a carpetbag and some loose shirts in the room Behan had been staying in at the Connors' house, but he did not find Behan's straw hat. During his cross-examination, Wines noted that he was not at the Connors' house to search for the straw hat in particular. Instead, he was there in his official capacity to collect the prisoner's belongings and to aid in the search for Behan.[306] Wines said that he had been told that Mrs. Wickham's name was on the trunk; however, the trunk he searched had the brass nameplate torn off.[307] At the conclusion of Wines's testimony, the prosecution rested its case.

The defense then called Peter Connor, their first witness, to the stand. Connor testified, "I reside in Greenport and keep boarders. I was not on terms of intimacy with the prisoner before he came to my house."[308] Behan had slept at the Connors' on Thursday, May 31, and Friday, June 1. Connor continued, "Nicholas said he was going to the brickyard on Monday morning and wanted to leave his trunk till then. The night before the murder...Pat Barey [a fireman on the railroad], Nicholas and myself took supper together. Nicholas was not at my house at nine o'clock that night." Connor went on to explain that on the morning after the murder he had seen Behan coming downstairs sometime after seven o'clock. "He come downstairs in his shirt sleeves," Connor said. "He had no coat on. He had his vest on and pants

and was in his stocking feet. I bid him good morning, and that was all that passed between us. I then went to my work." After a short pause, Connor continued, "I saw him after he was taken in the barn. I don't know where he spent the evening of Friday. I did not perceive anything peculiar about Nicholas that morning."[309]

Behan apparently thought that Connor's testimony was proof positive that he could not have committed the murders. While Connor spoke, Behan sat at the defense table with "disgusting levity…[he] laughed and grinned at the replies of his former associate in a manner which betrayed a want of every attribute of decency and common feeling."[310] After Connor's testimony, the court adjourned for the day to reconvene at eight o'clock the next morning.

That evening, attendees of the trial had a chance to catch up with the news of the nation. The *New York Herald* ran an article on a letter from the governor of the Hudson Bay Territories, Sir George Simpson, detailing the sad fate of the Franklin Expedition to the Artic.[311] The *New York Tribune* noted several troublesome issues, including the United States' attempts to annex the Dominican Republic, the growing unrest in Kansas between slave and abolitionist factions and the loss of life in the ongoing struggle at Sevastopol in Crimea.[312]

October 26 was the second and last day of Behan's trial. When the doors opened to the spectators, the court was again packed with anxious viewers. One reporter noted that on the third day, more women were in the room than on the previous two days and that Behan's "countenance was still as unconcerned as when he first pleaded 'Not Guilty!' to the charge."[313]

Samuel Phillips, the Suffolk County sheriff, returned to the stand to testify about an issue that was a clear conflict of interest. Regarding Behan's ride to Riverhead, Phillips said, "I was in the carriage with him. Dr. Carpenter, the driver and Mr. Preston were also in the carriage. Dr. C rode up to the jail with us."[314] Behan's lawyer then asked Phillips about his other occupation. Phillips replied, "I edit a paper called the *Republican Watchman*."[315] He was then handed a copy of the paper. Samuel Craig asked Phillips, "Did you write the article that appeared in the June 10th edition of the paper entitled "Murder at Cutchogue?" Phillips replied, "I did. It is a true account of the prisoner's confession." Phillips elaborated that the confession was elicited by questioning the prisoner and that "this statement gives his replies without the interrogatories."[316] The sheriff stated that all he had asked was, "What time did you go to Mr. Wickham's that night?" Behan responded calmly to the question. It was apparent that Phillips's instincts as a newspaper reporter overcame his duty as a public official when presented with the opportunity

to write up the "inside story" of the case. The fact that he was prejudicing every reader who saw the article against Behan apparently never entered his mind. Phillips said that he made no promises to Behan and did nothing to compel him to confess. However, he did note that when he started questioning Behan in the carriage, there was "considerable noise, firing of guns, &c, and several persons came part of the way with us on horseback. I heard not threats to hang him. He did not seem to be alarmed. He asked for some refreshments and complained some of the wound in his throat—of the bandage being too tight."[317]

After a quick conference between the defense and prosecution, Phillips's article was then read aloud in the courtroom. As Samuel Craig read the section in the account that stated that Behan had thought about killing the Wickhams a week prior to the event, he paused and questioned Phillips about the statement. Phillips replied haughtily, "Those are the very words of the prisoner."[318]

David C. Smith, who was the owner of an oyster saloon in Greenport, was next to be questioned.[319] He attested that Behan had patronized the saloon before the murder and had ordered a beer. Smith said he did not know if Behan actually drank the beer, but he remembered that Nicholas seemed "somewhat excited" and was wearing a cap. They spoke generally about women and the difficulties that Behan was having in understanding them.[320] A hushed laugh rippled through the courtroom.

Levi Preston, one of the local constables, was called next to give his testimony.[321] Preston, who lived in Greenport, stated, "On the first part the evening of the 2nd of June I was home and in bed as usual. It was not far from 9 o'clock when I went to bed that night. About ten o'clock, I was called up and went to the Wyandank House [Hotel], which was kept by Mr. Conklin. I did not know the prisoner then." Preston then gave Behan a long look and said, "But I do now."[322] At the time, the only person he remembered seeing was Captain John Clark, a former sheriff. He did not remember seeing Behan at the hotel. The first time he remembered seeing Behan "was in Overton's barn, after his arrest. He was lying very quiet on his back in the straw. There was blood on his neck; the doctor was dressing it."[323] Preston vaguely remembered the prisoner speaking to the doctor after the wound had been taken care of. He was more aware of various statements from other search party members—statements such as "shoot him" or "hang him." Nevertheless, Preston didn't think that any "threats were made designedly to injure him."[324] He noted that the other members of the search party that had gathered at the barn were willing to stand aside when they

were asked to do so. He then added, "From his appearance and acts, there was nothing which led me to think his mind was not right. He was quite free in conversation in the carriage and all the way to Riverhead."[325]

Next to be questioned was Florence "Flores" McCarthy, who worked for James Wickham's father, William Wickham Sr. McCarthy testified that Nicholas Behan often said that "he liked James first rate."[326] He noted that Behan had come to William Wickham Sr.'s house "about four or five days before the murder."[327] On Wednesday, Behan left William Wickham's and traveled to Greenport but returned on Thursday and asked to stay overnight again. McCarthy spoke to James Wickham about Nicholas's departure and was told, "Nicholas wanted to go, and he had better let him go."[328] When questioned about Behan's headwear, McCarthy stated that he saw him wearing a cap and that he had not seen a straw hat among the items Behan had brought from James Wickham's farm. McCarthy continued that Behan had breakfasted at William Wickham's on Friday morning, and that "after breakfast, he went to the field with us, but he did not get work with me. I went to work and have not seen him from that time until this day."[329] He also testified, "I do not know as Nicholas was engaged to Ellen. It was reported that he had mind to marry her. I guess he was a passionate fellow if he was put to it—I have seen him mild."[330]

John Delaney was the last witness called to the stand for the defense. He stated that Behan had told him that Ellen Holland was the reason he was fired from his job and that "he intended 'to spoil her modesty' the first chance he could get."[331] The prosecutors looked at each other with astonished glee, while the defendant's attorneys groaned in frustration, dumbfounded that their witness, who was supposed to help establish Behan as a hardworking and reasonable man, had made such a statement. After Delaney's testimony, the defense rested its case, and the court recessed until after dinner.

When the court resumed, the lawyers began to sum up their cases for the jury. Samuel D. Craig and Spicer Dayton, the lawyers for the defense, began their summation by noting that they were in an embarrassing position because the community had already convicted Nicholas Behan before his trial. Craig then went over the details of the case, reminding the jury that the relationship between the prisoner and James Wickham was amicable and that Nicholas Behan had always spoken well of James Wickham. Craig contended that Nicholas Behan was innocent of the crime of premeditated murder but conceded that Behan had entered the house that night. He asked the jury, "But who could tell that Mr. Wickham was not killed in a conflict with him, and if so, was it not then manslaughter instead of murder?"[332]

Craig cited the fact that Behan had tried to get on with his life by getting another job in Greenport at the brickyard. On the night the Wickhams died, he had dinner in Greenport, and his only objective in going to the Wickhams' house was to see Ellen Holland, "who was the only person against whom he had any cause for malice, if he really had such a feeling against anyone."[333] Craig finished his summation by defining the provisions of the law that related to manslaughter. He asked the jury to find Nicholas Behan guilty of manslaughter—not premeditated murder—in the case of the death of James Wickham.

Next, Ogden Hoffman, the attorney general of New York, gave the summation for the prosecution. Hoffman spoke about the details of the murder, starting from the point at which Behan left the Wickham's employ. He noted each step in each of the three attacks. Hoffman pointed out "their brutal mutilations," as well as the escape of Ellen Holland and Catherine Dowd. The attorney general also talked about John Thompson's testimony of Behan's threat, his condition when he was found in the swamp, his informing Ellen Holland that the crime was all her fault and his confession to Dr. Carpenter.[334] He noted that "the long chain of evidence which had wound itself around the prisoner…established his guilt [and] that when taken in connection with his confession, it eliminated every doubt upon the subject."[335]

Hoffman finished by exhorting the jury to believe that what was usually thought of as mercy was in this case a miscarriage of justice. He said that if the jury wanted to correct an injustice, then mercy could not be considered.[336] At the close of the prosecution's summation, the jury retired, and the court went into recess.

Chapter 10
THE VERDICT

After the defense and prosecution rested, the jury retired to deliberate. Twenty minutes later the jury returned to render its verdict in the case. Behan, the newspapers commented, appeared more like a spectator than a man about to hear his fate. When the jury foreman was asked by the court clerk to read the judgment, Behan leaned forward eagerly to hear the verdict. His face did not change expression when the ruling of guilty was read aloud.

Judge Strong then announced that he would sentence the prisoner the following morning at eight o'clock and adjourned the court. As Behan was led away back to his cell, someone in the crowd reportedly said, "Well Nick, wouldn't you rather it was finished at once?!" "Yes sir," Behan replied.[337]

On the morning of October 27, the court reassembled at eight o'clock. The courtroom was as crowded as it had been the previous three days. Behan entered the courtroom with a cheerful expression, smiling at the onlookers. After reading the jury's verdict to the prisoner, the court clerk asked him if he had anything to say about why the death penalty should not be applied in this case. Behan replied:

> *Well, all I have to say is that I ain't guilty of the crime that has been charged upon me. I knew those who did it, but I never prevented it, and now I won't turn traitor against any man. I never will let anyone have it to say after I die that I was a traitor. I didn't do it—it was John Scott and James McCrawden. They are the only ones that committed it, and*

I know it. They gave a dollar apiece that day to cross the Sound down near Greenport.[338]

The audience was somewhat shocked at Behan's attitude for several reasons. For one, his accusation that Scott and McCrawden committed the crime was universally declared to be untrue because the two men, who were transient workers, were not reported as being in the area during the time period the murders were committed. Secondly was Behan's reversal within his own statement. The fact that he said he wouldn't "turn traitor against any man" but in his next breath accused two other men of committing the murder was held up in the press as additional evidence of his poor character.[339]

The judge asked Behan if he had anything else to say. Behan responded, "That is all I got to say any further about it. I was in the knowledge of the murder and never wanted to prevent it."[340] Strong then reviewed the circumstances of the case before passing judgment on Behan, which he pronounced in a clear, resounding voice from the bench: "That you, Nicholas Behan, on Friday, the 15th day of December next, between the hours of 12 at noon and 2 in the afternoon, be hanged by the neck till you are dead. And may the Lord have mercy upon your soul."[341]

Behan's reply to Judge Strong was probably meant to be cheeky; however, when he opened his mouth to speak, the words must have come out somewhat strangled with shock because the *Tribune* and *Herald* reporters each heard something different. The *Herald* reported Behan retorting, "Thank you sir, and I will leave you my hair for a wig." This was a distinct jab at the judge, who was known to keep to the old ways and wore a wig over his own hair as a symbol of his profession. The *Tribune* quoted Behan as saying, "Thank you sir, and I will leave you my hair for a ring."[342] Taking hair from the deceased was a very common mourning practice at the time. The hair was often used as a remembrance in various pieces of jewelry or household decorations. Behan was reported to be muttering to himself as he was led away, but no one could hear what he was saying.[343]

Behan was returned to his cell in the old courthouse building to wait for a month and a half for his execution. The exact location of Behan's cell in the building is unclear, but it appeared to be either partially underground or above ground and reinforced with stone. He did not wait quietly for the end. He fought to escape from his imprisonment every chance he got. Daniel Edwards, the jailer, finally had to chain his arms and legs. After several weeks, the cuffs on Behan's arms were released, and he instantly tried to escape from his cell.

Lock and key from the door of the original Suffolk County Jail where Nicholas Behan was held. *Courtesy of Suffolk County Historical Society.*

In November, Behan was interviewed by a reporter, who wrote:

> *He has since become penitent and hopes to be forgiven his great crimes. He seemed reconciled to his fate and exhibited a sociable humor and readiness to enter into conversation. He said the only comfort he had was chewing tobacco and appealed to our sympathies for some money to replenish his stock of the weed, which we responded to by a small donation for which he expressed himself very thankful. He says he intends to meet his fate like a man and make a full confession of his crimes. He certainly seems to possess a great deal of animal courage. "Rum," said he "may claim me for a victim, for if it had not been for it, I would not be here.*[344]

Behan might have seemed resigned to his interviewer, but he had not finished exploring options to escape his fate. He tried to escape again by setting his cell on fire, which he must have had second thoughts about because he extinguished the fire using his own wash water.[345] At another point, he decided to try and starve himself to escape his hanging. Behan refused all the food brought to him. After several days, he could not continue

his self-imposed hunger strike and began eating again. Behan spent some time scraping at the old mortar between the rocks of his cell, attempting to loosen enough blocks to crawl out.[346]

As the execution approached, Behan began to break mentally and managed to convince himself that he was not Nicholas Behan. He decided that his name was really Hennigan, although he had never told anyone that. He spent a considerable amount of energy trying to convince Daniel Edwards and anyone else who would listen that he could not be the prisoner because his name was not Behan.[347] On December 7, he seized another chance for an escape attempt. While jailer Daniel Edwards was in his cell, Behan seized Edwards's arm and bit him severely. He nearly crippled Edwards with pain, but his plan was foiled when another man came in to see what the commotion was about.[348] About the same time, after a visit with his priest, he took advantage of being released from the manacles to rip up the floorboards in his cell, apparently hoping to be able to find a way out from under the foundation of the building. When Daniel Edwards came to investigate the noise, Behan quickly pushed his cot over the hole, hoping to conceal his newest plan. He was unsuccessful and again cuffed to prevent further escape attempts.[349]

Behan's personality changed after this final attempt. In the last days of his life, he was described as quiet and introspective. At one point, he called over Daniel Edwards and asked if the gallows being assembled in the yard behind the jail were for him. When Edwards answered in the affirmative, it was reported that he had a tear in his eye and exclaimed the same words used by Judge Strong weeks before: "May the Lord have mercy on my soul."[350] That evening, when he was brought his supper, Behan apologized for the disruptions his escape attempts had caused in the jail. "It is all over for me now," he said.[351]

The day before his execution, Behan's priest, Father McCarthy, came and spent several hours with him in prayer. It was during this time that Behan asked the priest to make known that he felt he was innocent of the crime he was being executed for. He also forgave and did not bear any ill will toward the community or the court for his trial or sentencing. Behan also wanted Ellen Holland to know that he forgave her and bore no ill will toward her, although he added that he felt her testimony "swore away his life."[352] After the priest left, Behan talked a woman prisoner in the neighboring cell into singing an Irish song while he began dancing a vigorous jig. He then spent some time carving on the wall of his cell: "Nicholas Behan executed December 15, 1854."[353]

The spectacle of a public execution had long been a popular event that often turned out huge crowds of people. The New York State government felt that allowing the public to view the death of the convicted helped to maintain the social order by acting as a deterrent against crime. Schools were often closed so that students could attend the event. Hangings often took on a fair-like quality, with vendors setting up booths along the edges of the crowd.[354] Local businessmen usually took advantage of the large gathering to sell food, drink and, sometimes, souvenirs.[355] During the 1830s, the New York State government began to doubt the effectiveness of allowing the general public to witness capital punishment. It was felt that instead of coming away with the lesson that crime doesn't pay, the crowd reveled in the brutality of the event. In several instances across the United States, when a criminal was reprieved from execution, riots broke out when the gathered crowds expressed their disappointment. To discourage onlookers, the state passed legislation that required that fences be erected to prevent all but a select group of government and legal representatives from witnessing the act.[356]

The gallows that was erected in the Riverhead jail yard had a long history of use in Suffolk County. The scaffold was constructed out of a local oak tree in the 1830s for the execution of William Enoch. It was a counterweight style of gallows in which the condemned was hoisted upwards when a weight was released. The gibbet was designed not to break the neck of the condemned for a quick death but so the victims would strangle for as long as twelve minutes before dying.[357] After each use, the scaffold was then disassembled and stored in the jail until it was needed again. Behan was the sixth man to be executed in Suffolk County since the American Revolution and the fourth executed on the Suffolk County counterweight gallows.[358] The day before the hanging, the gibbet was taken out of storage and was erected in the prison yard behind the jail. After the scaffold was in place, workers pieced together a closely fitted twenty-foot-tall pine-board fence, which enclosed the area of execution and would block the crowd from witnessing Behan's death.

That same day, December 14, people anxious to be a part of the execution began to gather in Riverhead. The temperatures were pleasant, as the weather on Long Island had started to warm after being gripped by an early cold snap.[359] Groups of people already gathered for the event were augmented when the afternoon train arrived from Brooklyn, bringing with it a "large number of men, women and children, all wishing to be present on the awful occasion."[360] To make sure Behan wouldn't try any last-minute escapes that evening, four men were posted in and around his jail cell.[361]

Early nineteenth-century flag of the Suffolk Guard. *Courtesy of Suffolk County Historical Society.*

The morning of the execution, Behan was served breakfast and allowed to visit for several hours with Father McCarthy.[362] He was then left alone in his cell for an hour to compose himself. The crowds outside the jail swelled to an estimated three thousand, with more continuing to arrive. Owners of nearby buildings were selling viewing spots on the upper floors and roofs to eager tourists. Officials called in the Suffolk Guard of Greenport and posted them around the newly built fence to prevent the crowds from ripping the barrier down. After some scuffling with people, who reluctantly gave up peepholes in the barrier, the guard managed to force the throngs back away from the fence.[363]

At 11:00 a.m., Samuel Phillips and several witnesses entered Behan's cell. Phillips asked Behan about his state of mind and the fate that was awaiting him. Phillips then ordered Behan's chains removed, which required a blacksmith.[364] Dressed in the traditional white shroud and cap, Behan was again allowed to meet with his priest for final prayers. Then Phillips, S. Wells Phillips, Stephen J. Wilson, David H. Huntting and Assistant Deputy Sheriff Lewis G. Davis returned to tie Behan's hands for execution.[365]

At 12:05 p.m., Behan was led from his cell to the jail yard. The weather had turned as warm and pleasant as May.[366] His priest, Samuel Phillips and

Muster roll of the June 1854 Suffolk Guard (Suffolk Troop), who were called to duty to keep the crowds from tearing down the fences surrounding the gallows. *Courtesy of Suffolk County Historical Society.*

the deputy sheriffs accompanied him to the scaffold. Walking with a firm step toward the gallows, he prayed aloud the whole way. "Arriving at the foot of the gallows, he continued in earnest prayer, repeating the sentence, 'Lord have mercy on me…Christ have mercy on me…Lord have mercy on my soul!'"[367] Samuel Phillips read aloud the death warrant and the execution order and asked Behan if he had any reason why the execution should not be carried out. Behan made no reply but continued to pray aloud.

The rope was attached to the beam above the condemned man, and Nicholas Behan said goodbye to his priest by shaking his hand. The rope was then placed around Behan's neck, and the rope holding the counterweight aloft was cut and the weight dropped. Nicholas Behan's body was hoisted up several feet in the air, where witnesses said he struggled for only three seconds before all motion of his body ceased. One minute after the hanging, the body was checked for signs of life. The pulse rate was sixty. At two minutes, a pulse of eighty-four was found. At three minutes, his pulse was sixty-four. When checked again after five minutes, no pulse could be found. Nicholas Behan, age twenty-four, was declared dead. The body was left hanging on the gallows for forty minutes so that officials could be assured that their task was completed.[368] The crowds of people that had gathered in hopes of gaining a glimpse of the hanging gradually dispersed. Many, undoubtedly hurried along by the thought of telling others about the execution, rushed to get back on board the trains that had brought them out to Riverhead.

The body was then cut down from the scaffold, placed in a plain pine box and carried on an old wagon to an unsanctified grave. Behan's body was accompanied only by the gravedigger and Father McCarthy.[369]

Chapter 11

THE AFTERMATH

I f Behan's act of murder and execution epitomized the failure of the American dream, then Ellen Holland's life was its successful fulfillment. A few years after the trial, Holland met a fellow native of Ireland, Daniel Haggerty. The two courted and, in due course, were married. They settled in Riverhead, not far from where the infamous trial had taken place.[370]

In 1865, the couple decided to move to Cutchogue, where so many of the events in this story had taken place.[371] There they were able to purchase a farm and begin to make a life for themselves. It was a time of change, as older, more established families began selling off their farms to new residents like the Haggertys. The descendants of the original settlers were no longer interested in simply farming; they wanted to be businessmen and professionals like accountants, doctors and attorneys.

On their farm, the Haggertys tilled the land, raised animals and produced three daughters; Rose, Mary and Frances.[372] They were successful as partners, and as the years went by, they created a large and successful enterprise that became the envy of their neighbors. As one publication noted, they became widely recognized for their charitable works and were among the most respected residents of the village.[373]

Following Daniel Haggerty's death in 1894, Ellen Haggerty continued her work as manager of the farm and took in the family of her daughter Rose, whose husband had also died in 1894 and left her with several young children. All three of the Haggerty daughters married well. Rose married Joseph Shalvey, a prominent merchant; Frances married Christopher J.

Gravesite of Mr. and Mrs. Daniel Haggerty in Sacred Heart Cemetery in Cutchogue. Mrs. Haggerty was the former Ellen Holland, who went from servant girl to respected community matriarch. *Authors' image.*

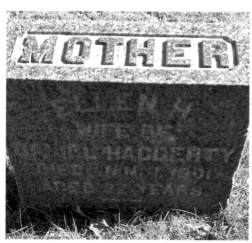

Detail of Ellen Holland Haggerty's grave marker. *Authors' image.*

Burns, the son of a Greenport, Long Island farmer; and Mary married Michael J. Garvey, the son of a Mattituck, Long Island farmer.[374] Later in life, Ellen even had her own servants: Pauline Kowartky, a Polish immigrant, and Irish immigrant Patrick McBride.[375] She had come full circle, becoming the mistress of the house, a prosperous businesswoman and an important member of a community in which she had once served others.

When Ellen died in 1901 at the age of eighty-two, several local and regional papers remarked on her death. She was called "one of the oldest and most widely known residents" of Cutchogue and a "highly respected and valuable member of the community."[376] They noted that her considerable wealth was the result of " thrift and industry" and that "much valuable property and a snug fortune was realized" through her and her late husband's efforts.[377] There was no mention of the Wickham murders reported anywhere at the time of her death.

Though an active member of the Sacred Heart Catholic Church in Cutchogue, she and her late husband were buried in St. Patrick's Cemetery, located

in Southold, as Sacred Heart did not yet have its own burial ground.[378] When Sacred Heart finally established a cemetery, the family removed their remains back to Cutchogue, where they would join other family members over the ensuing decades.[379]

The Wickham relatives moved on as well. William Wickham Sr., James's father, lived another five years before his death in August 1859, just two months shy of his eighty-sixth birthday.[380] The large farm owned by Frances and James Wickham at the time of their murders was left to Wickham's brother William Wickham Jr. The family continued to farm the land, eventually planting large orchards in addition to the traditional fields of corn and other vegetables. Their descendants continue this tradition to this day, still tilling the same land and producing much of the same crops. In addition, the family has branched into other specialty items, becoming particularly known far and wide for their delicious doughnuts.

Behan's name would not be completely forgotten. Decades later, in 1910, workers discovered a skeleton at the construction site of the new county jail in Riverhead. Little remained of the body, with many of the smaller bones having dissolved over time. Dr. Robert G. Cornwell was called in to

Suffolk County Courthouse showing the 1854 octagon jail, which was under construction during Behan's imprisonment. *Courtesy of Suffolk County Historical Society.*

Suffolk County Courthouse showing the newly expanded jailhouse, circa 1910. Behan's body was discovered during the construction and moved to an unknown location. *Courtesy of Suffolk County Historical Society.*

examine the burial. He stated that the bones were undoubtedly the remains of Nicholas Behan and that "he remembered the horrible murder and the hanging of Behan when he was a boy."[381] Today, Behan's exact burial location is unknown, as it is unclear where these bones were sent.[382]

Many of the local participants in the murders and subsequent trial—whether they remained here after the event or moved away—were joined together again in death. In the Cutchogue Cemetery, which was opened in 1858 on the north side of Main Road, members of the Fleet, Carpenter and Wickham families lie closely together near the center of the cemetery. William Wickham Jr. lies close to Dr. Benjamin Carpenter, who had long ago left for the shore of New Jersey but was returned here for burial three decades later. Nearby is the grave of Frances Post Wickham, daughter of Henry Wickham, who was born in 1855 and named for her recently murdered aunt.[383] Their granite monuments are a permanent reminder of their deep feelings for the community in which they worked and lived.

While the Wickham murders would not be the last ones committed in Suffolk County, they were perhaps the only murders that occurred at such a crucial moment in Long Island's history. It was the beginning of the transition of the large, expansive farms of eastern Long Island from

the descendants of the original settlers of the seventeenth century to new, immigrant populations. The murders brought this conflict to the forefront and helped to set in motion a push to limit access to these populations. This failed, of course, as more and more of them arrived each year to work in the fields and to purchase farms—not only those of Irish descent but those of German and Polish backgrounds as well. And it would be the Polish who would bring with them and introduce the potato to the area, forever transforming farming on eastern Long Island.

Chapter 12
THE PEOPLE

There is always a desire to know more about the characters that participated in a major event like the Wickham murders. Other than the main participants—whose fates have already been discussed—there are innumerable people whose fates the reader may be interested in knowing more about. Below are short biographies that discuss what happened to those involved after the execution of Nicholas Behan. It is interesting to note that within twenty years of Behan's execution, many of those involved were themselves deceased.

WILLIAM M. BETTS remained in Cutchogue, where he managed his varied business interests, including his general store and hotel. He got a taste for county politics and in 1858 ran for the position of county sheriff on the Democratic ticket. He was involved in another murder case a few years later, helping to negotiate the surrender of his friend Charles Jefferds, who was accused of the murder of his stepfather, Charles Walton, in New York City in 1860. Betts continued to live in Cutchogue, where he purchased and operated a prosperous farm and occasionally served as the local auctioneer. He is buried in the Cutchogue Cemetery.

WILLIAM P. BUFFETT was a fixture of the courts and county politics for many years following the trial, as he had been for decades prior to that event. Though he had first been nominated for public office around 1827, his longevity as a jurist was remarkable considering the constant turnover

in county politics. He resided for many years in the village of Northport, part of Smithtown Township in Long Island, where he died in 1874. When he died, many prominent lawyers, including Judge Selah B. Strong and former Suffolk County district attorney William Wickham, eulogized him in local papers. Judge Henry P. Hedges of Bridgehampton remarked upon his passing, "As a lawyer, he was a model of conscientious purity, fidelity, and excellence...in all respects, a thoroughly honest man."

DR. BENJAMIN D. CARPENTER continued his practice in Cutchogue. Having been through the legal process up close, he too became interested in county politics. In the fall of 1854, he ran unsuccessfully for the position of "Superintendent of the County Poor." Beginning in the early 1860s, he was heavily involved in Democratic Party politics in Suffolk County, serving as county convention chairman in 1861. He became a well-known expert on tetanus and was reported to have had great success in its treatment. He retired in 1874 with a "small fortune" and moved to Jersey City, New Jersey. He was involved with one other great trial in 1878, the poisoning case of the *State v. the Reverend George B. Vosburgh*. He died in Jersey City in 1885 and was buried in Cutchogue.

Grave of Dr. Benjamin Carpenter, the local doctor who treated James and Frances Wickham at the murder scene. *Authors' image.*

ENOCH F. CARPENTER returned to his home and business in Greenport and continued to serve as a justice for the court of sessions for Suffolk County. Like so many of the other individuals in the case, Carpenter continued in the political ring, running for clerk of Suffolk County in 1855 on the American Party platform. He lost that election by just thirteen votes. He was nominated to run for the New York State Assembly in 1857 but declined the nomination. In 1856, he was elected assistant chief of one of the newly

formed fire protection companies in Greenport and later served as chief. By 1870, he had moved to Texas, where he worked as a doctor alongside his son even though neither had the requisite training. A few years later, in 1872, Carpenter was elected mayor of the city of Rockport, located along the Gulf Coast. He died in Newport, Texas, in 1883 and was buried in the Liberty Cemetery in Clay County.

SAMUEL D. CRAIG was already an old man at the time of Behan's trial, and following its conclusion, he returned to his summer home in Quogue along Long Island's southern coast. Worn out by age and infirmity, he died there less than two years later at the age of seventy-nine. Few remarked upon the passing of this once noted and respected New York City legal mind. His grandson and namesake, Samuel D. Craig Jr., also became an attorney and continued the tradition of residing in Quogue started by his grandfather.

SPICER D. DAYTON returned to his legal practice in Riverhead. In 1859, just eight years into his marriage, his wife died tragically at the age of thirty-three. Dayton continued to live and work in Riverhead, first from the home of his late wife's family and later from the U.S. Hotel. He died in 1872 at the age of fifty-three, having never won the big case he hoped for. His fellow attorneys, who were much affected by his death, passed a resolution at the time of his passing that noted that he was "a sagacious and able advocate and an upright and enlightened citizen."

CATHERINE DOWD does not appear to have remained on eastern Long Island after the murders. She may have moved west to Brooklyn, where work was easier to find. In 1860, a woman of her name and age was working as a servant in the Brooklyn home of Anthony Lane, a master gas fitter.

DANIEL R. EDWARDS continued in his position as jailer for the County of Suffolk through 1856, when he left office. Other than the fact that he was a resident of Baiting Hollow, little else is known about him.

ALEXANDER HADDEN continued his practice of law in Queens and Brooklyn, where he would be involved in another infamous murder trial, that of James Kelly in 1858. In 1860, he and his wife celebrated the marriage of their daughter Emily to John Mumford Jr. He and other prominent individuals worked to obtain the release of Joseph Jackson, who had been wrongly convicted of rape and sentenced to prison. Never

tiring of politics, he left the Whigs and joined first the Union and then the Republican Party and ran for Queens County judge in 1865. After the end of the Civil War, he served as counsel to the Hempstead and Jamaica Railway Company. He died suddenly in November 1866, much mourned by all who knew him.

OGDEN HOFFMAN continued as attorney general of New York State through the end of 1855. He soon became involved in the legal challenges surrounding the will of millionaire businessman Henry Parish, and many of his associates felt the rigors of the case helped contribute to his "final illness." His health began to deteriorate in the spring of 1856, and he died in May of that year at the age of sixty-one. Heartbroken, many of New York's best-known judges and lawyers crowded together in the U.S. District Courtroom to comment upon his life and devotion to his craft. They resolved that they would "cherish his memory because of the noble example he has presented for our imitation—because of the lessons his life taught so forcibly to us all, namely to be ever mindful in every act of our professional career and that, as ministers of the law, like him, we are exercising the divine attribute of administering justice among men." His funeral was exceptionally well attended, and among his pallbearers were General Winfield Scott and Commodore Matthew Perry. He was laid to rest in the burial vault of St. Mark's Church in Manhattan.

HENRY HUNTTING returned to Southold, where he continued his involvement with the recently formed Southold Savings Bank, of which he was the treasurer and secretary. He remained on the board of the bank for thirty years in addition to serving as a local justice of the peace for twenty-five years and as treasurer of the First Presbyterian Church of Southold for thirty years. When he died in 1896, he left considerable sums of money to local charities, including the church and the Southold Academy. It was said at the time of his death that "he was [an] eminently generous man."

JOHN JONES went from being an unknown laborer to a celebrated local resident. His reward money enabled him to purchase a farm in Mattituck—he would never again have to work for someone else. By 1870, he was able to hire a servant to work in his home and later his very own farm hand. His son Charles also became a farmer and continued to reside in Mattituck on the North Road before retiring to a home on a street named "Love Lane."

BARNABAS W. OSBORN continued as a police magistrate in New York City following the trial. He left office in 1863 after having served twenty-two years as a justice. After his departure from his government position, he re-entered private practice as an attorney. In the fall of 1869, he and his wife, Letitia, gave their daughter Emmie away in marriage to Joseph A. Heleu. Osborn continued to work right up until his death, which occurred in March 1887 at the age of seventy-nine. At the time of his death, he was recalled as "the oldest surviving police justice" of New York City.

SAMUEL PHILLIPS continued to edit the well-known local newspaper he founded, the *Republican Watchman*, and remained active in Suffolk County politics. When he died in 1858, just four years after the trial and execution of Nicholas Behan, the *Sag Harbor Corrector* noted, "During the political life of Mr. Phillips…[he was] drawn into many political controversies—some of them of an embittered and malignant nature—but these, we believe, had all been 'amicably adjusted.'"

SELAH BREWSTER STRONG remained a New York State Supreme Court justice until 1859, the same year in which he left the position of ex-officio judge of the court of appeals. He served as a delegate to the Constitutional Convention of New York State during 1868 and 1869. He retired to his estate on Strong's Neck, named "St. George's Manor," located just north of the village of Setauket, Long Island. He died there in 1874 and was buried in the family cemetery located on the estate. It was noted upon his death that "he was in every respect a representative of another epoch, both in his convictions and manners, and was truly a gentleman of the olden times."

JOHN THOMPSON continued to live along Boisseau Avenue in the hamlet of Southold. Two of his children, Joseph and Mary, worked alongside their father on the family farm. He showed interest in helping out other immigrants, employing men of Irish descent to labor upon his farm when he could. His son James lived the immigrant parent's dream, becoming a doctor who lived and worked in Baltimore, Maryland.

WILLIAM WICKHAM JR. continued as district attorney until his term concluded at the end of 1854. He declined to run for political office for a number of years while he managed his successful law practice, Wickham & Case. When he did run again, during the 1870s, he was defeated twice for

county judgeships. Injured during a fall in February 1881, Wickham developed lockjaw and died a few weeks later. The *Long Island Traveler* remarked at the time of his death that he "was a great friend of the poor man and espoused his cause as gladly as he did that of his wealthy clients." He is buried in the Cutchogue Cemetery.

Right: Grave of William Wickham Jr., Suffolk County district attorney and brother of James Wickham. *Authors' image*.

Below: Detail of William Wickham Jr.'s grave. *Authors' image*.

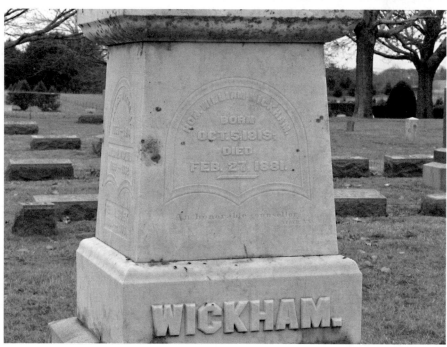

STEPHEN WINSTON was the only one of Behan's victims to survive his injuries, and he made a good recovery and lived on into adulthood. He moved back to New York City, where he had resided prior to coming out to Cutchogue. There Winston lived with his wife, Julia, on Sullivan Street and found employment as a laborer in a carriage shop. It is not known when or where he died.

NOTES

Chapter 1

1. Whitaker, *Whitaker's Southold*, 54–55.
2. Hoadly, *Records of the Colony and Plantation of New Haven*, 463; Tooker, "Analysis of the Claims of Southold," 14.
3. Goodrich, ed., *Southold Town Records*, 395–98; Whitaker, *Whitaker's Southold*, 60.
4. Craven, *A History of Mattituck*, 18. Occabauck was corrupted to become Aquebogue.
5. Ibid., 26–27.
6. Peconic was for a brief time renamed Hermitage by the Long Island Railroad, which apparently found the name of one of the nearby houses more attractive than the hamlets' Indian-derived name.
7. Craven, *A History of Mattituck*, 18.
8. Whitaker, *Whitaker's Southold*, 131–32. Oysterponds was the land of what is today East Marion and Orient. Occabauck is approximately the land from Aquebogue to either Riverhead or Wading River, while Cutchogue encompassed half of Mattituck and present-day Cutchogue.
9. Craven, *A History of Mattituck*, 32.
10. The lot that today composes both the Cutchogue business district and the peninsula that contains the hamlet of New Suffolk, which lies south of Cutchogue and was originally owned by John Booth. The name must have been coined in the 1840s or '50s since Oregon became a territory in 1848.
11. The Wickham family came to the New World when Thomas Wickham moved from England to Wethersfield, Connecticut, around 1648. Thomas established a wool merchant business, while his wife, Sarah, ran a school. They had a family of eight children, of whom seven survived into adulthood. Thomas's fifth son was Joseph.

12. Mather, *The Refugees of 1776*, 635.

13. Wicks, *Heaven and Earth*, 204.

14. Frost, *Ancestors of James Wickham*, 5.

15. Ibid., 8. Two children died in infancy.

16. Goodrich, ed., *Southold Town Records*, 168, 173, 377–79, 386–87, 190, 195, 198, 210.

17. Ibid., 199.

18. Ibid., 58, 217.

19. The house still stands and is known as the Old House of Cutchogue. The house was originally built by John Budd in 1649 and was given to his daughter Anna and her husband, Benjamin Horton. When Anna and her husband passed away, the house and land were inherited by Benjamin's brother Joseph. Joseph Horton in 1690 and sold the house and property to Joseph Wickham. The house was moved from Southold to Cutchogue in 1661. See Kitt Barrett's "Benjamin Horton House Historic Structures Report, 1990" at the Cutchogue-New Suffolk Free Library, Cutchogue, Suffolk County, New York.

20. Wicks, *Heaven and Earth*, 62–64, 205. According to Alexander Flick's research in *Loyalism in New York During the American Revolution*, an old civil list book in the Suffolk County clerk's office (copy owned by O.B. Ackerly, former Suffolk County Clerk) states that the Cutchogue farmland was purchased not by Jared Landon but by Nathaniel Norton for £900.

21. Frost, *Ancestors of James Wickhan*, 10.

22. Ibid., 10–12.

23. It was not unusual in the 1700s for near relatives to marry. The only legal ban was that brothers and sisters could not marry, but it was not infrequent for cousins or other near relatives to wed.

24. William Wickham Jr., *Unpublished Genealogy of Wickham Family*. Original held by the Oysterponds Historical Society, Orient, Suffolk County, New York.

25. *Republican Watchman*, "New Arrangement." It is possible this James Wickham from Connecticut is involved with an 1847 grocery venture with Justus Dill and G.W. Bell in Howells Depot, New York (Orange County), but there is no way to be certain. A short time later, a farm in Orange County is advertised for sale by a James Wickham. The advertisement asks interested parties to contact said James Wickham at a New York City address.

26. *Fredonia Censor*, "List of Letters," September 1839.

27. Dorothy Lindgren, compiler, Westhampton Presbyterian Church Records, undated, copy of original held by the Suffolk County Historical Society, Riverhead, Suffolk County, New York.

28. *Sag Harbor Corrector*, "Mortgage Sale," July 26, 1851; *Sag Harbor Corrector*, "Mortgage Sale," November 20, 1844.

29. Mather's *Refugees* notes that during the American Revolution, the majority of the Howell family lived in Mattituck, with several smaller branches of the family living on the South Fork. Frances was born to one of the smaller branches of the family.
30. *Syracuse Daily Journal*, "New York, June 4, 7 P.M.,"June 7, 1854.
31. *New York Herald*, "The Horrid Murders on Long Island," June 5, 1854.
32. *Syracuse Daily Journal*, "Paper Warehouse," 1851.
33. One of these ventures was in the Reciprocity Bank of Buffalo. James's stock ownership was advertised in the newspaper when the bank went bankrupt. James's brother William, who had inherited his farm, and another brother, John, were named as the administrators of his estate in the newspaper and were listed as representing his shares. See *Buffalo Daily Courier*, "In the Matter of the Application," 1858.
34. Bayles, *Historical and Descriptive Sketches*, 369.
35. Folk, "General Store on Long Island," 25–30, 44–46, 50.
36. Ibid., 10.
37. See John Chace Jr.'s 1858 "Map of Suffolk County, Long Island, New York."
38. Ibid.
39. Bayles, *Historical and Descriptive Sketches*, 369–70.
40. When Joseph Albertson died, he still owed $9,200 on the farm.
41. *Republican Watchman*, "Mortgage Sale," August 10, 1850.
42. See Southold Town Assessment Rolls 1854. Even though the Wickhams were living at the time in upstate New York, James Wickham listed Brooklyn as his residence on the deed. This may have led to the earlier researcher's assumption that he was living in Brooklyn.
43. *New York Daily Tribune*, "The Long Island Double Murder," June 7, 1854.

Chapter 2

44. The farms of the Catholic majority began to shrink due to confiscation of property by the government anti-Irish inheritance laws. The new inheritance laws did not follow the English practice of primogeniture, which kept the property whole and intact for the next generation. They demanded that land be split among all of the sons of the family. This practice rapidly shrank the large and moderate farms into smaller and smaller parcels that could barely support a family. Catholics were also barred from purchasing property, voting, joining the army, holding office, practicing law and owning a sword or gun. During the 1700s, the average farmstead began to shrink dramatically as the population began to explode. See Laxton's *Famine Ships*, 18–21.
45. Crosby Jr., *The Columbian Exchange*, 66, 183.
46. Ibid., 182.

47. Ibid., 183.

48. Ibid., 49–53.

49. *New York Herald*, "Execution of Nicholas Behan," December 17, 1854.

50. *Sag Harbor Corrector*, "The Horrid Murder at Cutchogue," June 7, 1854.

51. *Sag Harbor Corrector*, "Brief History of the Murderer," June 14, 1854.

52. Wikipedia, "Thomas Nast," http://en.wikipedia.org/wiki/Thomas_Nast.

53. In Bridgehampton, New York, the Corwith sisters sold land located along Montauk Highway to a Polish man, who in turn deeded the land over to the church. (This land would soon become home to the Queen of the Most Holy Rosary Roman Catholic Church.) This basically "cleansed" the sisters of any wrongdoing, as they had not sold the land to the church directly.

54. Letter to William Wilson Stephenson from his mother, Mrs. Mark Stephenson, 6 August 1851, copy held in the collection of the Southold Historical Society, Southold, Suffolk County, New York.

55. "Brief History of the Murderer," *Sag Harbor Corrector*, 14 June 1854.

56. "New York Passenger Lists, 1820-1957," www.ancestry.com (accessed Winter 2011-2012). Behan is mentioned as arriving on this ship on 5 September 1851, in New York City.

57. Palmer, "Palmer List of Merchant Vessels." The *Constellation* was in service between 1849 and 1867, longer than most vessels.

58. Ibid.

59. Immigrant Ships, "Immigrant Ships, Transcribers Guild, Ship Connecticut."

60. Palmer, "Palmer List of Merchant Vessels." Though the average was about forty-three days, ships like the *Constellation* could do it in as little as twenty-two days or as long as fifty-nine days depending on weather and sea conditions.

61. Huber, "Understanding Your Ancestors."

62. Ibid.

63. Wikipedia, "The New York Times," http://en.wikipedia.org/wiki/The_New_York_Times.

64. Moreno, *Castle Garden and Battery Park*, 7–8.

65. Ibid.

66. Huber, "Understanding Your Ancestors."

67. Jackson, ed., *Encyclopedia of New York City*, 584.

68. *Sag Harbor Corrector*, "Brief History of the Murderer," June 14, 1854.

69. Ibid.

70. Ibid. Though the paper reports that these jobs were up to a year in length, this is not possible. Behan was in America only from September 1851 to June 1854 before the murders took place, so some of these positions must have been less than a year in length, perhaps only a few months at most.

71. City University of New York, "Cholera in 19th Century New York."

72. James K. Polk Memorial Association, "James K. Polk Biography," http://www.jameskpolk.com /new/biography.asp.
73. *New York Daily Times*, "Employment Procured for Immigrants," January 1, 1853.
74. *New York Tribune*, "Advertisement," March 15, 1852.
75. Ibid.; *Sag Harbor Corrector*, "Brief History of the Murderer," June 14, 1854.; *New York Herald* "Emigrant Labor Exchange," October 2, 1868. It is known that Behan had registered at the exchange and that Mr. Wickham hired him through the service. Exactly who J.P. Fagan was is unknown. Obviously, his name hints that he too was Irish, but it is unknown if he was born in Ireland. The exchange continued to operate through 1868, when they published a semi-monthly report of their hiring statistics.
76. *Brooklyn Daily Eagle*, March 17, 1852.
77. Ridge, "Irish Town and Local Societies."
78. David Kerkhof, "1850 Federal Census of Southold Town." Enumerated by J.G. Tuthill, July 8–August 3, 1850.
79. *Long Island Traveler*, "Recollections of Southold," August 30, 1877. The article notes, "The first Irishman known in the village was employed by Hazard Moore at the hotel, and his name was 'Jimnaic.'" This was probably Jimmie Yack, whose unusual surname survived locally for many years. The article continues, "The lively sons of Erin were a rarity till the grading of the railroad, and the first land-holders were John O'Neal and John Thompson. The former bought of John F. Boisseau his portion of 'Old Lot' and the latter purchased the 'Norkutt Lot,' now owned by Mrs. Geo. Maier."
80. *Brooklyn Daily Eagle*, "Opening of the Long Island Rail Road," July 21, 1844.
81. Ibid.
82. *Brooklyn Daily Eagle*, "Long Island Railroad—1847," April 10, 1847.
83. *Brooklyn Daily Eagle*, "Long Island Railroad Company—Spring Arrangement," May 12, 1845.
84. *Brooklyn Daily Eagle*, "The Long Island Murders—Confession of the Assassin," June 7, 1854. One of the witnesses, Ellen Holland, remarked that Behan had "worked for Mr. Wickham for over two years."
85. Suffolk County Criminal Court, "Ellen Holland, Inquest Testimony, June 3, 1854."
86. Wikipedia, "County Monaghan," http://en.wikipedia.org/wiki/County_Monaghan.
87. *New York American*, June 9, 1840.; *New York Herald*, June 1, 1857.
88. Unfortunately, the name Ellen Holland is fairly common. In the years 1848 to 1851, nine women named Ellen Holland from the British Isles traveled to the United States. Three of the women fairly closely match the facts of Ellen Holland of Monaghan and Cutchogue. After analyzing each of the women, the authors believe that the woman on the *Robert Parker* is the correct immigrant.

89. In a medium or large household, jobs such as a cook required a broad knowledge and the ability to prepare a variety of dishes, while the job of a lady's maid would have required expertise in the care of fancy fabrics and other required items of apparel.

90. Burnett, *Useful Toil*, 136–38, 142–54.

91. Johnson, *A Shopkeeper's Millennium*, 43–45.

92. Suffolk County Criminal Court, "Ellen Holland, Inquest Testimony, June 3, 1854."

93. By the mid- to late 1850s, Ellen's sister (name unknown) and a second brother, Peter, had also immigrated to the States.

Chapter 3

94. Suffolk County Criminal Court, "Catherine Dowd, Inquest Testimony, June 3, 1854."

95. Johnson, *A Shopkeeper's Millennium*, 44.

96. *New York Daily Times*, June 7, 1854.

97. Catherine Dowd arrived from Ireland on the ship *Enterprise* on July 12, 1851, at age twenty-one. She started work at the Wickhams' farm about a year later. See National Archives, "Catherine Dowd."

98. Demos, *A Little Commonwealth*, 107–08; Johnson, *A Shopkeeper's Millennium*, 44.

99. Suffolk County Criminal Court, "Ellen Holland, Inquest Testimony, June 3, 1854."

100. Larkin, *Reshaping of Everyday Life*, 138. Mattresses were generally stuffed with a variety of items. Some popular stuffing included grasses, feathers, corn husks or whatever was at hand in the area the person lived in.

101. Suffolk County Criminal Court, "Ellen Holland, Inquest Testimony, June 3, 1854."

102. Ibid.

103. Suffolk County Criminal Court, "William Betts, Inquest Testimony, June 3, 1854." According to the July 8, 1854 issue of the *Republican Watchman*, the cost of a ticket to Brooklyn on the Long Island Rail Road in June was two dollars. As of mid-July, the price had gone up to two dollars and twenty-five cents.

104. *New York Herald*, "Trial of Nicholas Beehan," October 27, 1854.

105. Suffolk County Criminal Court, "Florence McCarthy, Inquest Testimony, June 3, 1854."

106. Suffolk County Criminal Court, "John Delany, Inquest Testimony, June 3 1854."

Chapter 4

107. Wikipedia, "Kansas-Nebraska Act," http://en.wikipedia.org/wiki/Kansas-Nebraska_Act; Johannsen, *Stephen A. Douglas*, 434–70.
108. Fleming, *Southold*, 57.
109. Mercer, *Ancient Carpenter's Tools*, 175.
110. *Sag Harbor Corrector*, "The Horrid Murders at Cutchogue," June 7, 1854. The newspapers noted that a blood trail was left by Behan's "stocking feet," indicating he was wearing only socks while maneuvering through the house.
111. Suffolk County Criminal Court, "Benjamin D. Carpenter, Exploratory Witness Testimony, June 6, 1854."
112. See "United States Federal Census of 1850" enumerated by Thomas R. Disbrow. Stephen Winston is listed as living with his family in 1850, indicating that he arrived in Cutchogue after early August 1850, perhaps around the same time that Behan was hired.
113. *Sag Harbor Corrector*, "The Horrid Murders at Cutchogue," June 7, 1854.
114. *New York Herald*, "The Trial of Nicholas Beehan," October 26, 1854; Suffolk County Criminal Court, "Benjamin D. Carpenter, Exploratory Witness Testimony, June 6, 1854."
115. *Sag Harbor Corrector*, "The Horrid Murders at Cutchogue," June 7, 1854; Suffolk County Criminal Court, "Samuel Phillips, Exploratory Witness Testimony, June 6, 1854."
116. *Sag Harbor Corrector*, "The Horrid Murders at Cutchogue," June 7, 1854.
117. Ibid.
118. Suffolk County Criminal Court, "Benjamin D. Carpenter, Exploratory Witness Testimony, June 6, 1854."
119. *Sag Harbor Corrector*, "The Horrid Murders at Cutchogue," June 7, 1854.
120. Ibid.
121. Ibid.; Suffolk County Criminal Court, "Catherine Dowd Inquest Testimony, June 3, 1854."; Suffolk County Criminal Court, "William M. Betts, Exploratory Witness Testimony, June 6, 1854." Though the *Corrector* states that they traveled together, Dowd in fact traveled on her own to Betts's house while Holland headed to the Corwin home.
122. *New York Herald*, "The Trial of Nicholas Beehan," October 26, 1854.
123. *Sag Harbor Corrector*, "The Horrid Murders at Cutchogue," June 7, 1854.
124. Suffolk County Criminal Court, "Benjamin D. Carpenter, Exploratory Witness Testimony, June 6, 1854." According to Carpenter, Behan stated that he had "found the girls were gone and attempted to find his way back as he came but could not [and] thus he thus passed then the room of Mr. Wickham and got out of the window there."; *New York Tribune*, "Murder Cases," October 26, 1854.
125. Tiffany, *Reports of Cases Argued and Determined*, 550–63.

NOTES TO PAGES 39–42

126. *Sag Harbor Corrector*, "The Horrid Murders at Cutchogue," June 7, 1854; Suffolk County Criminal Court, "William M. Betts, Exploratory Witness Testimony, June 6, 1854." Betts noted in his later testimony, "She stated that she [Dowd] believed someone was murdering Mr. and Mrs. Wickham and begged some of us to come down."

127. Suffolk County Criminal Court, "William M. Betts, Exploratory Witness Testimony, June 6, 1854."

128. Ibid; Suffolk County Criminal Court, "Ellen Holland, Exploratory Witness Testimony, June 6, 1854; "United States Federal Census of 1850."

129. *Sag Harbor Corrector*, "The Horrid Murders at Cutchogue," June 7, 1854.; Suffolk County Criminal Court, "Benjamin D. Carpenter, Exploratory Witness Testimony, June 6, 1854."

130. Suffolk County Criminal Court, "William M. Betts, Exploratory Witness Testimony, June 6, 1854."

131. *Sag Harbor Corrector*, "The Horrid Murders at Cutchogue," June 7, 1854.

132. Suffolk County Criminal Court, "Benjamin D. Carpenter, Exploratory Witness Testimony, June 6, 1854.

133. Ibid.; *Sag Harbor Corrector*, "The Horrid Murders at Cutchogue," June 7, 1854. Carpenter notes that the jaw was broken in two places. Mrs. Wickham died at about 2:00 a.m., just two hours after the attacks commenced. James Wickham lingered for almost twenty-four hours, dying at 8:00 p.m. on Saturday night.

134. *Sag Harbor Corrector*, "The Horrid Murders at Cutchogue," June 7, 1854.

Chapter 5

135. See "United States Federal Census of 1850."

136. *Sag Harbor Corrector*, "The Horrid Murders at Cutchogue," June 7, 1854.

137. Ibid.

138. Ibid.

139. Suffolk County Criminal Court, "Florence McCarthy, Inquest Testimony, June 3, 1854."

140. *Sag Harbor Corrector*, "The Horrid Murders at Cutchogue," June 7, 1854.

141. Ibid.

142. Ibid.

143. *New York Daily Times*, "The Wickham Murder," June 7, 1854.

144. See John Chace Jr.'s 1858 "Map of Suffolk County, Long Island, New York."

145. "United States Federal Census of 1850."

146. *Sag Harbor Corrector*, "The Horrid Murders at Cutchogue," June 7, 1854.

147. Ibid.

148. Ibid.; *Long Island Traveler*, "Recollections of Southold," August 30, 1877. John Thompson was one of the first Irish immigrants to own land in the hamlet of Southold.

149. Ibid. Based on Behan's confession, the *New York Daily Tribune* reported a slightly different reply from Thompson: "You are the murderer...you can't pass out of here. If you do, then I shall shoot you."

150. Ibid. The *New York Daily Tribune* reported that Thompson was already armed and had aimed his gun at Behan's breast when he accused him.

151. Ibid; *New York Daily Tribune*, "The Long Island Double Murder," June 7, 1854.

152. *Sag Harbor Corrector*, "The Horrid Murders at Cutchogue," June 7,1854. Another source states that John Thompson sent his son to get help.

153. Ibid.

154. Ibid.

155. Ibid.

156. Ibid.

157. Ibid; *New York Daily Tribune*, "The Long Island Double Murder," June 7, 1854.

158. *New York Daily Times*, "The Cutchogue Murder," June 7, 1854. The paper noted that "none attended service" that day.

159. *Sag Harbor Corrector*, "The Horrid Murders at Cutchogue," June 7, 1854.

160. *New York Daily Tribune*, "The Long Island Double Murder," June 7, 1854.

161. See John Chace Jr.'s 1858 "Map of Suffolk County, Long Island, New York."

162. *New York Daily Tribune*, "The Long Island Double Murder," June 7, 1854.

163. *Long Islander*, "Horrible Murder," June 9, 1854.; *New York Daily Tribune*, June 7, 1854.

164. *New York Herald*, October 26, 1854. J. Wickham Case notes that Behan was found in the swampy area behind Halsey Haynes's house, which was situated on the eastern edge of Goldsmith's Inlet in Peconic.

165. Ibid; *New York Daily Times*, "The Wickham Murder," June 7, 1854.

166. *New York Daily Tribune*, "The Long Island Double Murder," June 7, 1854.

167. *New York Daily Times*, "The Long Island Murder," June 6, 1854.

168. Ibid.

Chapter 6

169. *New York Daily Tribune*, "The Long Island Murder—Capture of the Murderer—Great Excitement," June 6, 1854.

170. Bayles, *Historical and Descriptive Sketches of Suffolk County*, 290–91. The 1841 trial was that of Samuel Johnson, who ended up being executed for the murder of his wife.

171. "William Wickham (1819-1881)," http://freepages.genealogy.rootsweb. ancestry.com/~jwickham/ william.htm.

172. Wikipedia, "Ogden Hoffman," http://en.wikipedia.org/wiki/ Ogden_Hoffman.

173. Ibid.

174. Hall, "Ogden Hoffman," 297–300.

175. Ibid. Seward became the twelfth governor of New York State, a state senator and the U.S. secretary of state under Abraham Lincoln and Andrew Johnson.

176. *New York Herald*, "The Late Ogden Hoffman," May 4, 1856.

177. Williams, *The Life of Washington Irving*, 348.

178. Hall, "Ogden Hoffman."

179. Ibid.

180. Ibid.

181. Wikipedia, "Ogden Hoffman," http://en.wikipedia.org/wiki/ Ogden_Hoffman.

182. *New York Daily Tribune*, "Brooklyn Items," October 9, 1854.

183. Chester and Williams, *Courts and Lawyers of New York*, 964.

184. Holley, ed., *The New York State Register for 1843*, 409.

185. *Brooklyn Daily Eagle*, "Decease of Alexander Hadden—Testimonial of the Kings County Bar," November 8, 1866; *Queens County Sentinel*, "Died," November 15, 1866.

186. *Long Island Farmer and Advertiser*, "At a Convention of Whigs of Queens County," October 1842.

187. *Long Island Farmer and Advertiser*, "Whig Nomination," May 27, 1851.

188. *Long Island Farmer and Advertiser*, "Official Canvass," January 1852.

189. *Long Island Farmer and Advertiser*,"Queens County Court," July 1, 1845.

190. *New York Daily Tribune*, "Trial of Samuel Drury for Subornation of Perjury," December 17, 1852.

191. *Long Island Farmer and Advertiser*, "County Court," December 21, 1852.

192. Allegheny College, *Register of Alumni and Non-Graduates*, 19.

193. The Code Reporter, *Journal for the Judge*, 73.

194. *Long Islander*, "Suffolk County Circuit Court and Court of Oyer and Terminer," September 17, 1852.

195. *Long Islander*, "Suffolk County Courts," March 18, 1853.

196. Other notables from his class included: Oliver Young (b. 1811), who served as an attorney and civil engineer in Port Jervis, New York; William F. Groshon (b. 1827), who became a justice of the peace in Yonkers, New York; Joseph S. Ridgway, who became a prominent attorney in Brooklyn (where his son Joseph W. later became district attorney); John H.C. Remington (b. 1824), who worked as an attorney in Brooklyn; Charles

Powers, who was an attorney in Dutchess County, New York; Daniel Bookstaver (1828–1903), who worked as an attorney and became mayor of Syracuse; Gilbert O. Hulse (b. 1824), who was a prominent attorney and one-time town clerk and surrogate of Orange County, New York; John Berry (d. 1915), who was a prominent attorney, member of the state assembly and one of the founders of the New York City Bar Association; John J. Armstrong, who worked as an attorney in Jamaica, Queens, and became district attorney for Queens County and served as a Queens County judge; and A. Jackson Hyatt (d. 1893), who worked as an attorney and town clerk in White Plains, New York. These biographical snippets are derived from a number of sources, many of which are included in the bibliography of this publication.

197. *Long Islander*, "Suffolk County Courts," March 18, 1853.
198. Ibid; *Long Islander*, "Circuit Court for Suffolk County," September 10, 1851. Dayton and Rose also worked together on the case *Benjamin v. Horton*.
199. Clark, *List of Attornies and Counsellors*, 30.
200. *The Lady's Weekly Miscellany*, May 21, 1808.
201. *New York Evening Post*, May 2, 1811; *New York Evening Post*, February 1820.
202. Marke, *Catalogue of the Law Collection*, 1019.
203. Ibid.
204. *Sag Harbor Corrector*, "Law Notice," August 31, 1839.
205. Ostrom, Pollin and Savoye, *Collected Letters of Edgar Allan Poe*, 459–60.
206. Ibid. The authors note, "Little is known about Samuel D. Craig, and just what the present letter refers to is unknown. The mention of Willis suggests that it may have concerned some matter in regard to the *New-York Mirror*, recently recast as a daily (evening) and weekly paper."
207. *Long Islander*, "Suffolk County Circuit Court and Court of Oyer and Terminer," September 17, 1852.

Chapter 7

208. Dicken-Garcia, *Journalistic Standards*, summary leaf.
209. Baldasty, *Commercialization of News*, summary leaf.
210. University of California-Santa Barbara, Office of Public Affairs, "Sex and Murder in the City—19th Century Style," August 13, 1998.
211. Wikipedia, "New York Herald," http://en.wikipedia.org/wiki/New_York_Herald.
212. Ibid.
213. *Syracuse Evening Chronicle*, October 31, 1854.
214. *New York Herald*, "Horrid Murders on Long Island," June 4, 1854.
215. *New York Daily Tribune*, "Horrid Murders on Long Island," June 5, 1854.

216. *New York Daily Tribune*, "The Long Island Double Murder," June 7, 1854.
217. *New York Daily Tribune*, "Murder Cases—Trial of Nicholas Beehan," October 26, 1854.
218. *New York Herald*, "Trial of Nicholas Beehan," October 27, 1854.
219. *New York Daily Tribune*, "Horrid Murders on Long Island—Still Later Particulars," June 6, 1854. This article mentions that the other officer from the city was Constable Nesbitt. The *New York Daily Times* noted that the judge, Justice Barnabas Osborn, was from that part of Long Island and that "a posse of New York policemen have been selected to scour the woods and assist in bringing the murder to justice." See: *New York Daily Times*, "The Cutchogue Murder," June 5, 1854.
220. *New York Daily Tribune*, "The Long Island Double Murder," June 7, 1854.
221. *New York Herald*, "The Horrid Murders on Long Island," June 5, 1854.
222. *New York Daily Tribune*, "The Long Island Double Murder," June 7, 1854.
223. *New York Daily Times*, "The Wickham Murder," June 7, 1854.
224. Ibid.
225. *Brooklyn Daily Eagle*, "The Murders on Long Island: Arrest of the Assassin," June 6, 1854.
226. *Brooklyn Daily Eagle*, "Riverhead Affairs," November 16, 1854.
227. *Long Island Farmer and Advertiser*, "The Wickham Murder," June 13, 1854.
228. *Sag Harbor Corrector*, "The Horrid Murder at Cutchogue," June 7, 1854.
229. *Gallipolis Journal*, "Horrible Murder," June 15, 1854.

Chapter 8

230. Yeager, *Around the Forks*, 175.
231. Ibid.
232. Stark, *Riverhead: The Halcyon Years*, 4.
233. The courthouse was located on what is today West Main Street, between Griffing Avenue and Roanoke Avenue. The building stood until 1911, when it was torn down and replaced with a row of brick stores.
234. Dooley, *Sheriffs of Suffolk County*, 8–9.
235. Bayles, *Historical and Descriptive Sketches*, 288.
236. Timothy Dwight, "Journey to Long Island 1804" in *Journeys on Old Long Island*, 76.
237. Yeager, *Around the Forks*, 178.
238. Ibid., 177–78.
239. Phillips started the paper in 1826 in Sag Harbor. He moved the business in 1844 across Peconic Bay to Greenport. He served only one term as sheriff. See: Dooley, *Sheriffs of Suffolk County*, 35.
240. *Long Islander*, "The Long Island Murder," September 1, 1854.
241. *Long Islander*, "Behan, the Murderer," June 23, 1854.

242. Ibid.

243. *Long Islander,* "The Long Island Murder," September 1, 1854.

244. Ibid.

245. *New York Daily Times,* "Long Island," August 29, 1854.

246. *Utica Daily Gazette,* "The Horrible Murders at Cutchogue, Long Island," June 6, 1854.

247. *New York Daily Tribune,* "The Long Island Double Murder," June 7, 1854.

248. The Wickhams were buried in Mattituck because the Cutchogue Cemetery was full and a new cemetery had yet to be established. The new Cutchogue cemetery did not open until 1858.

249. *Long Islander,* "Funeral of Mr. & Mrs. Wickham," June 9, 1854. Frances had two brothers, John Howell Post and William Post. The newspapers do not say which brother attended the funeral.

Chapter 9

250. *Sag Harbor Corrector,* "Suffolk County Court of Sessions," October 11, 1854; *Long Islander,* "Certificate of the Election of County Officers," November 25, 1853; *Sag Harbor Corrector,* "W.P. Buffett," January 21, 1852.

251. *Sag Harbor Corrector,* "Suffolk County Court of Sessions," October 11, 1854.

252. *Long Islander,* October 13, 1854.

253. The French terms "oyer" and "terminer" mean to hear and determine, respectively. In New York State prior to 1896, all treasons, felonies and misdemeanors were prosecuted in the Court of Oyer and Terminer.

254. Gordon, *Gazetteer of the State of New York,* 284.

255. *New York Herald,* "Criminal News," October 25, 1854.

256. Case, Diary, October 24, 1854.

257. *Long Island Farmer and Advertiser,* "The Wickham Tragedy," October 31, 1854.

258. *New York Herald,* "Criminal News," October 25, 1854; *Long Island Farmer and Advertiser,* "The Wickham Tragedy," October 31, 1854.

259. *Long Island Farmer and Advertiser,* October 31, 1854.

260. *Long Islander,* October 13, 1854. In an interesting side note, Behan wasn't the only person from Cutchogue facing the court that day. Witness William M. Betts, accused of violating the excise law, also had to face the court.

261. *New York Herald,* "Criminal News," October 25, 1854.; *Sag Harbor Corrector,* March 3, 1877. Jurors were Charles V. Scudder farmer, Northville, age twenty-seven; William Vail, farmer, Peconic, age forty-five; Jeremiah Osborne, retired, East Hampton, age fifty; Hiram Wines, carpenter, Quogue, age thirty-nine; James E. Sandford, farmer, Bridgehampton, age forty-two; Albert L. Hedges, no occupation, Sag Harbor, age fifty-four; George B. Mills, farm laborer, Cold Spring, age forty; Herman

Strong, farmer, East Hampton, age thirty-one; Platt R. Hubbs, farmer, Commack, age forty-seven; Scudder S. Hawkins, no occupation, Islip, age forty-one; Brewster Derry, no information available; and John D. Edwards, carpenter, Miller Place, age thirty-two.

262. *Brooklyn Daily Eagle*, "Trial of Nicholas Beehan," October 25, 1854.

263. Ibid.; *New York Herald*, "Criminal News," October 25, 1854.

264. *New York Herald*, "Criminal News," October 25, 1854.

265. *New York Herald*, "Trial of Nicholas Beehan," October 26,1854.

266. *New York Herald*, "Criminal News," October 25, 1854. According to Webster's 1865 dictionary, the word "furnace" is used to describe any enclosed space where a fire is maintained to heat a house or bake bread. But considering the use of the word in the descriptions given by the various witnesses, the authors believe that the word is being used to describe either the built-in indoor laundry tub, which was often permanently set over a firebox, or the back of the baking oven, which was a large dome-shaped brick structure, usually located next to the laundry tub.

267. *New York Daily Tribune*, "The Long Island Double Murder," June 7, 1854.

268. In this instance, the word "intimate" means to start a relationship. It is not used in a biblical sense.

269. *New York Herald*, "Criminal News," October 25, 1854.

270. *New York Daily Tribune*, "Murder Cases," October 26, 1854.

271. The newspaper reporter misspelled the name. A branch of the family that does not live on the North Fork spells it Tuttle, but the branch of the family that lives in Cutchogue spells the name Tuthill.

272. *New York Herald*, "Trial of Nicholas Beehan," October 26, 1854.

273. *New York Daily Tribune*, "Murder Cases," October 26, 1854. An accommodations train is a passenger train.

274. *New York Herald*, "Trial of Nicholas Beehan," October 26, 1854. Tuthill had good reason to fear the Wickhams' dog—the couple owned a large male Newfoundland mixed-breed.

275. Ibid.

276. Ibid.

277. Ibid.

278. *New York Daily Tribune*, "Murder Cases," October 26, 1854.

279. *New York Herald*, "Trial of Nicholas Beehan," October 26, 1854.

280. *New York Daily Tribune* "Murder Cases," October 26, 1854.; *New York Herald*, "Trial of Nicholas Beehan," October 26, 1854.

281. During the inquest, Betts testified that Behan owed him ten dollars.

282. *New York Herald*, "Trial of Nicholas Beehan," October 26, 1854.

283. *New York Daily Tribune*, "Murder Cases," October 26, 1854.

284. *New York Herald*, "Trial of Nicholas Beehan," October 26, 1854.

285. Ibid.

286. *New York Daily Tribune*, "Murder Cases," October 26, 1854.

287. *New York Herald*, "Trial of Nicholas Beehan," October 26, 1854. Other witnesses also noted that Mrs. Wickham's nightgown was pulled up, but whether the exposure was a result of the struggle with Behan before her death or if Behan committed a sexual assault in addition to murder is unclear. It is possible that Carpenter was trying to ensure a conviction by suggesting a secondary assault.

288. Ibid.

289. *New York Daily Tribune*, "Murder Cases," October 26, 1854.

290. *New York Herald*, "Trial of Nicholas Beehan," October 26, 1854.

291. *New York Daily Tribune*, "Murder Cases," October 26, 1854.

292. *New York Herald*, "Trial of Nicholas Beehan," October 26, 1854.

293. Ibid.

294. Ibid.

295. Ibid.

296. Ibid. "Spirituous liquor" was the common description of hard alcohol. The term was used to distinguished it from beer, wine and hard cider. See: Folk, "General Store on Long Island," 44–45 and Brown, *Early American Beverages*.

297. *New York Daily Tribune*, "Murder Cases," October 26, 1854. The *New York Herald* reported the quote differently, writing that Behan called out, "Ask the witness if Mr. Wickham was in the wagon on the Wednesday or Thursday previous to the murder when Mrs. Wickham drove up to his [Mr. Betts's] store?"

298. *New York Herald*, "Trial of Nicholas Beehan," October 26, 1854.

299. Ibid. Prior to the Civil War, most pistols required a separate cap to ignite the gunpowder in order to fire the bullet. Although Behan apparently didn't have the gun loaded, the caps made a small explosive noise when the trigger was pulled and the hammer fell against it. See: "Testimony of Henry Moran, June 6, 1854."

300. Ibid.

301. *New York Herald*, "Trial of Nicholas Beehan," October 26, 1854.

302. *New York Daily Tribune*, "Murder Cases," October 26, 1854.

303. *New York Herald*, "Trial of Nicholas Beehan," October 26, 1854.

304. Ibid. "French Fiddles" may be a nickname for small bells. See *Progressive Batavian* "The Waking of Bells," June 20, 1879.

305. *New York Herald*, "Trial of Nicholas Beehan," October 26, 1854. Michael Marsh worked for James Wickham's brother John. In Spicer Dayton's interview with Ellen Holland just before the trial, he asked her about Behan's accusation that she had conspired with a man named Michael against Behan to get him fired from his job. She vehemently denied the charge. See "Testimony of Ellen Holland, June 6, 1854."

306. *New York Daily Tribune*, "Murder Cases," October 26, 1854.

307. *New York Herald*, "Trial of Nicholas Beehan," October 26, 1854.

308. Ibid.

309. Ibid.

310. *New York Daily Tribune*, "Murder Cases," October 26, 1854.

311. *New York Herald*, "The Arctic Region," October 25, 1854.

312. *New York Daily Tribune*, October 25, 1854.

313. *New York Daily Tribune*, "Murder Cases," October 27, 1854.

314. *New York Herald*, "Trial of Nicholas Beehan," October 27, 1854.

315. Ibid. The *Republican Watchman* was one of two popular newspapers printed in Greenport and distributed throughout the North Fork. The other paper was the *Suffolk Times*.

316. Ibid.

317. Ibid.

318. *New York Herald*, "Trial of Nicholas Beehan," October 27, 1854.

319. The saloon may have been in the Wyandank House Hotel. Although the authors have not been able to confirm its location, that is the only reason that makes sense in light of the beginning of Levi Preston's testimony.

320. *New York Herald*, "Trial of Nicholas Beehan," October 27, 1854.

321. *Sag Harbor Corrector*, "County Expenditures," December 2, 1854.

322. *New York Herald*, "Trial of Nicholas Beehan," October 27, 1854.

323. Ibid.

324. Ibid.

325. Ibid.

326. Ibid.

327. Ibid.

328. Ibid.

329. Ibid.

330. Ibid.

331. Ibid.

332. Ibid.

333. Ibid. The reporter for the *New York Tribune* somewhat sourly noted that Craig took two and a half hours to sum up his side of the case. It was apparent from the tone of the article that it was two and a half hours too long.

334. Ibid.

335. *New York Daily Tribune*, "Murder Cases," October 27, 1854.

336. Ibid.

Chapter 10

337. Ibid.

338. *New York Herald*, "Trial of Nicholas Beehan," October 27, 1854. There is no information available for either John Scott or James McCrawden. The two men were probably laborers who had traveled across the sound looking for work.

339. Ibid.

340. Ibid.

341. Ibid.

342. Ibid.

343. Ibid. The *New York Daily Tribune* reported Behan's exit differently. The paper wrote that he left the court with a sinister smile. Interestingly, Behan was sentenced and executed for the murder of James Wickham; he was never tried for the murder of Frances Wickham.

344. *Brooklyn Eagle* "Riverhead Affairs," November 16, 1854.

345. Ibid.

346. *New York Herald*, "Execution of Nicholas Behan," December 17, 1854.

347. *New York Herald*, "The Execution of Nicholas Beehan for the Murder of the Wickham Family," December 1854.

348. *Auburn Weekly Journal*, "Execution of Beehan," December 1854.

349. *New York Herald*, "Execution of Nicholas Behan," December 17, 1854.

350. *Auburn Weekly Journal*, "Execution of Behan," December 1854.

351. Ibid.

352. *New York Herald* "Execution of Nicholas Behan," December 17, 1854.

353. Ibid. The newspaper states that Behan wrote, "Nicholas Behan executed November 15, 1854." Apparently, Frances Wickham had taught Behan the basics of reading and writing.

354. Larkin, *Reshaping of Everyday Life*, 294.

355. Brandon, *The Electric Chair*, 26.

356. Larkin, *Reshaping of Everyday Life*, 294, 302.

357. Brandon, *The Electric Chair*, 26.

358. Yeager, *Around the Forks*, 181.

359. Case, Diary, December 14, 1854.

360. *New York Herald*, "Execution of Nicholas Behan," December 17, 1854.

361. Ibid.

362. Father McCarthy was stationed in Hicksville but also had Riverhead as part of his circuit. The Catholic Church had only started celebrating Mass in the area in 1844. See Bayles, *History of Suffolk County*, 17.

363. Ibid.

364. The reason for the blacksmith is unclear. The *New York Herald* simply reported that a blacksmith was called and that it took twenty minutes to remove the chains.

365. Ibid.; *Republican Watchman*, "List of Civil Officers in Suffolk County in 1854," January 21, 1854.

366. J. Wickham Case, Diary, December 15, 1854.

367. *New York Herald*, "Execution of Nicholas Behan," December 17, 1854.

368. This practice of leaving the body hanging for more than a half hour appears to be routine. In his book on executions in Connecticut, Lawrence Goodheart notes of other hangings during which bodies of the condemned were also left for at least half an hour.

369. *New York Herald*, "Execution of Nicholas Behan," December 17, 1854. The newspaper reported that Behan was buried in Jasper Vinli's woods, but Jasper Vinli might be a misprint, as the man does not appear in any source consulted.

Chapter 11

370. *Newtown Register*, "Recent Deaths," January 10, 1901.

371. Ibid.

372. *Brooklyn Daily Eagle* "Mrs. Ellen H. Haggerty," January 8, 1901.

373. Ibid.

374. Ibid.

375. See 1900 Census for Cutchogue.

376. *Brooklyn Daily Eagle* "Mrs. Ellen H. Haggerty," January 8, 1901.

377. Ibid.

378. Ibid.

379. Author's visit to the Garvey-Haggerty-Shalvey plot, October 2012, Sacred Heart Cemetery, Depot Lane, Cutchogue. Notes in author's files, Southold Historical Society, Southold, Suffolk County, New York.

380. Frost, *Ancestors of James Wickham*, 14.

381. *Long Islander*, "Old Murder Recalled," May 28, 1910.

382. As stated previously, it is believed that Behan's body was buried on the property of a Mr. Jasper Vinli on the outskirts of Riverhead Village. It is possible that sixty years later this parcel was selected for the new jail, but that is unknown at this time. The county courthouse where Behan was tried was located on Main Street, but in 1854, the Griffing farm was acquired, and Griffing Avenue opened. This included the site for the new courthouse, which was completed just a few years later.

383. Frost, *Ancestors of James Wickham*, 14.

BIBLIOGRAPHY

Allegheny College. *Register of Alumni and Non-Graduates*. Meadville, PA: The Tribune Company, 1915.

Ancestry.com. "New York Passenger Lists, 1820-1957."

———. "United States Federal Census of 1850," August 8, 1850.

Auburn Weekly Journal. "Execution of Beehan." December 1854.

Bailey, Paul. *Long Island: A History of Two Great Counties, Nassau & Suffolk* Vol. 1. New York: Lewis Historical Publishing Company, 1949.

Baldasty, Gerald J. *The Commercialization of News in the Nineteenth Century*. Madison: University of Wisconsin Press, 1992.

Bayles, Richard M. *Historical and Descriptive Sketches of Suffolk County*. Port Jefferson, NY: self-published, 1874.

———. *History of Suffolk County: The Town of Riverhead*. New York: W.W. Munsell and Company, 1882.

Black, Henry. *A Law Dictionary*. St. Paul, MN: West Publishing Company, 1910.

Brandon, Craig. *The Electric Chair: An Unnatural American History*. Jefferson, NC: McFarland, 1999.

Brighton, Terry. *Hell Riders: The True Story of the Charge of the Light Brigade*. New York: Macmillan, 2004.

Brooklyn Daily Eagle. "An Official with a History." August 9, 1896.

———. "Death of Henry Huntting." December 18, 1896.

———. "Decease of Alexander Hadden—Testimonial of the Kings County Bar." November 8, 1866.

————. "Execution of Beehan." December 16, 1854.

————. "Mrs. Ellen H. Haggerty." January 8, 1901.

————. "The Murders on Long Island: Arrest of the Assassin." June 5, 1854.

————. "Riverhead Affairs." November 16, 1854.

————. "Sentence of the Murderer Beehan." October 27, 1854.

————. "Trial of Nicholas Beehan." October 25, 1854.

Brown, John Hull. *Early American Beverages*. New York: Bonanza Books, 1966.

Burnett, John. *Useful Toil*. New York: Penguin Books, 1984.

Carpenter, Daniel Hoogland. *History and Genealogy of the Carpenter Family in America from the Settlement at Providence, R.I., 1637–1901*. Jamaica, NY: The Marion Press, 1901.

Case, J. Wickham. "Diary, 1854." Original held by the Southold Historical Society, Southold, Suffolk County, New York.

Chester, Alden and Williams, Edwin Melvin. *Courts and Lawyers of New York: A History, 1609–1925*. Clark, NJ: The Lawbook Exchange, 2004.

Clark, Aaron. *Manual Compiled and Prepared for the Use of the Assembly—List of Attorneys and Counselors at Law in the State of New York*. Albany, NY: J. Buel, 1816.

The Code Reporter. *A Journal for the Judge, the Lawyer, and the Legislator*. New York: The Code Reporter, 1849.

Craven, Charles E. *A History of Mattituck*. Mattituck, NY: Jedediah Clauss & Sons, 1988.

Crosby, Alfred W., Jr. *The Columbian Exchange*. Westport, CT: Greenwood Press, 1972.

Crouthamel, James L. *Bennett's New York Herald and the Rise of the Popular Press*. Syracuse, NY: Syracuse University Press, 1989.

Demos, John. *A Little Commonwealth*. New York: Oxford University Press, 1970.

Dicken-Garcia, Hazel. *Journalistic Standards in Nineteenth-Century America*. Madison: University of Wisconsin Press, 1989.

Dooley, Eugene T. *The Sheriffs of Suffolk County*. Riverhead, NY: Department of General Services, 1989.

Downs, Arthur Channing, ed. *Riverhead Town Records*. Huntington, NY: The Long Islander, 1967.

Elton, G.R. *The Tudor Constitution*. New York: Cambridge University Press, 1992.

Evangelical Independent Church. *The Trial in Full, of Edward Arrowsmith, for Slandering the Character of the Rev. Alexander Cumming, Minister of the Evangelical Independent Church, Rose Street, New York: With the Conviction (by Consent) of George Reeks for the Same Offence*. New York: S. Walker, 1819.

Fleming, Geoffrey K. *Images of America: Southold*. Charleston, SC: Arcadia Publishing, 2004.

Folk, Amy Kasuga. "The General Store on Long Island, 1810–1850." Masters thesis, Long Island University, 2008.

Frost, Josephine C. *Ancestors of James Wickham and His Wife Cora Prudence Billard*. Privately printed, 1935.

Gallipolis Journal. "Horrible Murder." June 15, 1854.

Gedge, Karin E. *Without Benefit of Clergy: Women and the Pastoral Relationship in Nineteenth American Culture*. New York: Oxford University Press, 2003.

Goodheart, Lawrence B. *The Solemn Sentence of Death: Capital Punishment in Connecticut*. Amherst: University of Massachusetts Press, 2011.

Goodrich, Magdaline, ed. *Southold Town Records, 1683–1856*. Southold, NY: Town of Southold, 1983.

Gordon, Thomas. *Gazetteer of the State of New York*. Philadelphia: Privately printed, 1836.

Hall, A. Oakey. "Ogden Hoffman." *The Green Bag* 5, no. 7 (July 1893): 297–300.

Hayes, Charles Wells. *William Wells of Southold and His Descendants, A.D. 1638 to 1878*. Buffalo, NY: Baker, Jones & Company, 1878.

Hearn, Daniel Allen. *Legal Executions in New York State*. Jefferson, NC: McFarland & Company, Inc., 1997.

Hoadly, Charles J. *Records of the Colony and Plantation of New Haven from 1638 to 1649*. Hartford, CT: Case, Tiffany and Company, 1857.

Holbrook, Dwight. *The Wickham Claim*. Riverhead, NY: Suffolk County Historical Society, 1984.

Holley, O.L., ed. *The New York State Register for 1843*. Albany, NY: J. Disturnell, 1843

Huber, Leslie Albrecht. "Understanding Your Ancestors—Voyage to the U.S." http://www.understandingyourancestors.com/ia/shipVoyage.aspx.

Immigrant Ships. "Immigrant Ships, Transcribers Guild, Ship Connecticut." http://www.immigrantships.net/v8/1800v8/connecticut18550523.html.

Jackson, Kenneth J., ed., *The Encyclopedia of New York City*. New Haven, CT: Yale University Press, 1995.

Johannsen, Robert Walter. *Stephen A. Douglas*. Chicago: University of Illinois Press, 1997.

Johnson, Paul E. *A Shopkeeper's Millennium*. New York: Hill and Wang, 1978.

Lambert, Edward Rodolphus. *History of the Colony of New Haven*. New Haven, CT: Hitchcock & Stafford, 1838.

Larkin, Jack. *The Reshaping of Everyday Life, 1790–1840*. New York: Harper Perennial, 1988.

Laxton, Edward. *The Famine Ships*. New York: Henry Holt and Co., 1996.

Long Island Farmer and Advertiser. "At a Convention of Whigs of Queens County." October 1842.

———. "County Court." December 21, 1852.

———. "Official Canvass." January 1852.

———. "Queens County Court." July 1, 1845.

———. "Whig Nomination." May 27, 1851.

———. "The Wickham Murder." June 13, 1854.

———. "The Wickham Tragedy." October 31, 1854.

Long Islander. "Behan, the Murderer." June 23, 1854.

———. "Certificate of the Election of County Officers." November 25, 1853.

———. "Circuit Court for Suffolk County." September 10, 1851.

———. "Funeral of Mr. & Mrs. Wickham." June 9, 1854.

———. "Horrible Murder." June 9, 1854.

———. "The Long Island Murder." September 1, 1854.

———. "Notice." September 15, 1854.

———. "Old Murder Recalled." May 28, 1910.

———. "Suffolk County Circuit Court and Court of Oyer and Terminer." September 17, 1852.

———. "Suffolk County Courts." March 18, 1853.

Long Island Traveler. "Recollections of Southold." August 30, 1877.

———. "The Traveler." May 22, 1873.

Marke, Julius J. *A Catalogue of the Law Collection at New York University*. Union, NJ: The Lawbook Exchange, 1999.

Mercer, Henry C. *Ancient Carpenter's Tools*. Mineola, NY: Dover Publications, 2000.

Moreno, Barry. *Images of America: Castle Garden and Battery Park*. Charleston, SC: Arcadia Publishing, 2007.

Naylor, Natalie A., ed. *Journeys on Old Long Island*. Interlaken, NY: Empire State Books, 2002.

Newtown Register. "Recent Deaths." January 10, 1901.

New York Daily Times. "The Cutchogue Murder." June 5, 1854.

———. "The Cutchogue Murder." June 7, 1854.

———. "The Long Island Murder." August 29, 1854.

———. "The Wickham Murder." June 7, 1854.

New York Daily Tribune. "Brooklyn Items." October 9, 1854.

———. "Execution of James Kelly." July 31, 1858.

———. "The Horrid Murders on Long Island." June 5, 1854.

———. "Horrid Murders on Long Island—Still Later Particulars." June 5, 1854.

———. "The Long Island Double Murder." June 7, 1854.

———. "The Long Island Murder—Capture of the Murderer—Great Excitement." June 6, 1854.

———. "Murder Cases." October 27, 1854.

———. "Murder Cases—Trial of Nicholas Beehan." October 26, 1854.

———. "Trial of Samuel Drury for Subornation of Perjury." December 17, 1852.

———. "The Wickham Murder." October 9, 1854.

New York Herald. "Criminal News—Trial of Nicholas Beehan." October 25, 1854.

———. "Execution of Nicholas Behan." December 17, 1854.

———. "The Execution of Nicholas Behan for the Murder of the Wickham Family." December 16, 1854.

———. "Executions." November 15, 1854.

———. "The Horrid Murders on Long Island." June 4, 1854.

———. "The Late Ogden Hoffman." May 4, 1856.

———. "Trial of Nicholas Beehan." October 26, 1854.

———. "Trial of Nicholas Beehan." October 27, 1854.

Ostrom, John Ward, Burton Ralph Pollin, and Jeffrey A. Savoye. *The Collected Letters of Edgar Allan Poe.* New York: Gordian Press, 2008.

Palmer, Michael C. "Palmer List of Merchant Vessels." New York Public Library.

Prime, Nathaniel S. *A History of Long Island.* New York: Robert Carter, 1845.

Progressive Batavian. "The Waking of Bells." June 20, 1879.

Queens County Sentinel. "Died." November 15, 1866.

Republican Watchman. "List of Civil Officers in Suffolk County in 1854." January 21, 1854.

———. "New Arrangement." February 1847.

Ridge, John T. "Irish Town and Local Societies in New York," *New York Irish History* 20, 2006.

Sag Harbor Corrector. "Brief History of the Murderer." June 14, 1854.

———. "Buffett, W.P." January 21, 1852.

———. "County Expenditures." December 2, 1854.

———. "The Horrid Murder at Cutchogue." June 7, 1854.

———. "Law Notice." August 31, 1839.

———. "Long Island Items." February 15, 1872.

———. "Mortgage Sale." November 20, 1844.

———. "Mortgage Sale." July 26, 1851.

———. "Obituary—Samuel Phillips, Esq." September 4, 1858.

———. "Suffolk County Court of Sessions." October 1854.

Sag Harbor Express. "The Death of Judge Buffet." October 22, 1874.

————. "Suffolk County Gallows Tree." December 9, 1886.

Sala, George Augustus. *America Revisited*. London: Vizetelly and Company, 1886.

Schama, Simon. *A History of Britain*. New York: Hyperion, 2000.

Stark, Thomas M. *Riverhead: The Halcyon Years 1861–1919*. Huntington, NY: Maple Hill Press, 2005.

Stephenson, Mrs. Mark. "Letter to William Wilson Stephenson," August 6, 1851. Copy held in the collection of the Southold Historical Society, Southold, Suffolk County, New York.

Suffolk County Criminal Court. "Capture of Information, June 4, 1854." Copy and transcription held in the collection of the Southold Historical Society, Southold, Suffolk County, New York.

————. "Confession of Nicholas Behan, June 6, 1854." Original held by the Suffolk County Historical Documents Library, Riverhead, Suffolk County, New York.

————. "Exploratory Testimony of Benjamin D. Carpenter, June 6, 1854." Original held by the Suffolk County Historical Documents Library, Riverhead, Suffolk County, New York.

————. "Exploratory Testimony of Ellen Holland, June 6, 1854." Original held by the Suffolk County Historical Documents Library, Riverhead, Suffolk County, New York.

————. "Exploratory Testimony of Samuel Phillips, June 6, 1854." Original held by the Suffolk County Historical Documents Library, Riverhead, Suffolk County, New York.

————. "Inquest Testimony of Catherine Dowd, June 3, 1854." Original held by the Suffolk County Historical Documents Library, Riverhead, Suffolk County, New York.

————. "Inquest Testimony of Ellen Holland, June 3, 1854." Original held by the Suffolk County Historical Documents Library, Riverhead, Suffolk County, New York.

————. "Inquest Testimony of Florence McCarthy, June 3, 1854." Original held by the Suffolk County Historical Documents Library, Riverhead, Suffolk County, New York.

————. "Inquest Testimony of Henry Moren, June 3, 1854." Original held by the Suffolk County Historical Documents Library, Riverhead, Suffolk County, New York.

————. "Inquest Testimony of John Delany, June 3, 1854." Original held by the Suffolk County Historical Documents Library, Riverhead, Suffolk County, New York.

———. "Inquest Testimony of Samuel Phillips, June 3, 1854." Original held by the Suffolk County Historical Documents Library, Riverhead, Suffolk County, New York.

———. "Inquest Testimony of Silas W. Carpenter, June 3, 1854." Original held by the Suffolk County Historical Documents Library, Riverhead, Suffolk County, New York.

———. "Inquest Testimony of William M. Betts, June 3, 1854." Original held by the Suffolk County Historical Documents Library, Riverhead, Suffolk County, New York.

———. "Suffolk County Inquest Juror Findings in Frances Wickham's Death, June 4, 1854." Copy and transcription held in the collection of the Southold Historical Society, Southold, Suffolk County, New York.

———. "Suffolk County Inquest Juror Findings in James Wickham's Death, June 4, 1854." Copy and transcription held in the collection of the Southold Historical Society, Southold, Suffolk County, New York.

Sweetman, John. *Balaclava 1854*. Westminster, MD: Osprey Publishing, 2012.

Thompson, Benjamin. *History of Long Island*. New York: E. French, 1839.

Tiffany, Joel. *Reports of Cases Argued and Determined in the Court of Appeals in the State of New York*. Vol. 4. Albany, NY: Weare C. Little, 1865.

Tooker, William Wallace. "Analysis of the Claims of Southold, L.I." *Magazine of New England History* (January 1892): 1–16.

Utica Daily Gazette. "The Horrible Murders at Cutchogue, Long Island." June 6, 1854.

Webster, Noah. *American Dictionary of the English Language*. Springfield, MA: G. & C. Merriam, 1865.

Whitaker, Epher. *Whitaker's Southold*. Mattituck, NY: Amereon House, 1997.

Wick, Steve. *Heaven and Earth*. New York: St. Martin's Press, 1996.

Williams, Stanley Thomas. *The Life of Washington Irving*. New York: Octagon Books, 1971.

Yeager, Edna Howell. *Around the Forks*. Interlaken, NY: I.T. Publishing Corporation, n.d.

ABOUT THE AUTHORS

G eoffrey K. Fleming is the director of the Southold Historical Society and serves on several regional boards, including the Long Island Museum Association. He specializes in the art and history of Long Island and is the author of several books, catalogs and articles concerning the subject, including the award-winning publications *A Shared Aesthetic: Artists of Long Island's North Fork*; *Ever Eastward: Alfred H. Cosden and His Estate at Southold*; and *Charles Henry Miller, N.A: Painter of Long Island*.

A my Kasuga Folk is the collections manager for the Southold Historical Society, the Oysterponds Historical Society and the Suffolk County Historical Society. A veteran of the museum world, she has worked with a number of other Long Island institutions, including the Old Bethpage Village Restoration. She is the coauthor of *Hotels and Inns of Long Island's North Fork* and the award-winning *Munnawhatteaug: The Last Days of the Menhaden Industry on Eastern Long Island*.